JFK

Cornell Capa

JFK
FOR PRESIDENT
photographs by Cornell Capa

edited by Richard Whelan and Kristen Lubben

International Center of Photography

STEİDL

CONTENTS

DIRECTOR'S FOREWORD

The International Center of Photography was founded thirty years ago by photojournalist Cornell Capa with the belief that photographs could be a powerful tool for the documentation of history as well as for social change. The pictures of John F. Kennedy's presidential campaign and the early days of his administration had been undertaken by Capa because he believed in Kennedy and was motivated to give the American people an inside view of what was happening.

Cornell started photographing Kennedy for *Life* magazine during the Wisconsin primary in 1960. After the election, he photographed the inauguration, and stayed on in the White House to photograph the first 100 days of the Kennedy administration. Although Capa was a working photojournalist covering breaking news, these pictures contributed to the mythology that built up around JFK. 1960 was also the very moment television surfaced as an important political tool. Kennedy was the first president to effectively use the new medium to create his image, both through debates as candidate and with the first televised press conferences as president. But it was also the heyday of *Life*, which seemed to sit on every coffee table in America, and long after the television images faded the power of the still photograph reinforced the charisma of the man, the charm and appeal of his wife and family, and the youthful energy of his administration.

Cornell developed a warm friendship with Jacqueline Kennedy early in 1961, while he was spending months in the White House photographing the family and the administration. Many years later, in 1974, she became a close ally in the effort to create ICP, one of the first museums devoted exclusively to photography. At Cornell's invitation, she joined ICP as a founding board member.

Her interest in photography was genuine. When she first met Jack Kennedy at a Washington dinner party in 1951, she was working as the "inquiring photographer" for the *Washington Times-Herald*. Soon after ICP's opening in November of 1974, an unsigned piece about the new institution written by Jacqueline Kennedy Onassis appeared in *The New Yorker*'s Talk of the Town section. She worked closely with Cornell to bring visibility and credibility to the institution, and much of its early success was due to her generous and gracious support.

This book and the exhibition that it accompanies represent the kind of project that was central to Cornell Capa's vision for ICP. His hopes included plans for exhibitions, publications, and a permanent collection that would encompass entire archives of photographers' prints, negatives, and papers. ICP's collection now includes over 100,000 images and the archives of important photographers as diverse as Weegee and Roman Vishniac, along with the Robert Capa and Cornell Capa Archives. The images in this book, many never before seen, were unearthed in the Cornell Capa Archive for this project by the exhibition's co-curators, Richard Whelan and Kristen Lubben.

It is a great pleasure for ICP to mount this exhibition and to co-publish the book that accompanies it, both to honor the memory of John F. Kennedy and to make accessible this important body of work by our Founding Director Emeritus. I extend my warmest thanks and appreciation to Cornell Capa for allowing us to do this project. Special acknowledgment is due to co-curators Richard Whelan, Curator of the Robert and Cornell Capa Archives at ICP, and ICP Assistant Curator Kristen Lubben, whose research and commitment brought these photographs to light. Several individuals at ICP have also been essential in making this project possible and I would like to thank them: Brian Wallis, Director of Exhibitions and Chief

Curator, who first suggested the exhibition and was integral to its development; Karen Hansgen, Publications Manager, who was instrumental in shaping and directing all aspects of this book; Erin Barnett, Curatorial Assistant, who provided crucial research assistance; Phil Block, Deputy Director for Programs; Anna Winand; Marie Spiller; Ann Doherty; editor Martin Fox; and ICP interns Nicole Heck and Lizz Torgovnick. I would also like to thank our Publications Committee under the energetic lead of Frank Arisman and Andrew Lewin. And much thanks and appreciation are due to Gerhard Steidl, our publications partner, Bernard Fischer for the innovative design, and the entire staff at Steidl Publishing for the outstanding production of this book. For helping to make the exhibition that accompanies this book a success, thanks to Teresa Engel Moreno, who made many of the prints, Robert Hubany, Karlos Carcamo, Barbara Woytowicz, and exhibition designers Alan Bruton and Alicia Cheng. Thanks also to Kathi Doak and her colleagues at the Time-Life Picture Collection; and to David Strettel and Malli Kamimura at Magnum Photos. And thanks to Alan and Phyllis Cooper for their kind donation of some of the prints that were used in the exhibition.

Finally, special thanks to the Alex Hillman Family Foundation, Stephanie and Fred Shuman, Bicky and George Kellner, Tony and Dominique Milbank, Ethel & Irvin Edelman Foundation, Estanne Abraham Fawer, Linda Hackett for C. A. L. Foundation, Lynne and Harold Honickman, The Liman Foundation, Mr. and Mrs. Ted Nierenberg, Ronny Schwartz, Marshall Sonenshine and Sonenshine Pastor & Co., and Lester Wunderman for their lead gifts. Further thanks to Eastman Kodak Company, Norman H. Gershman, Peter Howe, Herbert Keppler, Arthur and Dolores Kiriacon, Mara Vishniac Kohn, Magnum Photos New York, Magnum Photos Tokyo, Mamiya-MacGroup, Nikon Inc., Susan Unterberg, Claire and Richard Yaffa, and Lois and Bruce Zenkel for additional contributions. Without this support the book and the exhibition would not have been possible.

Cornell Capa believed that the history of the twentieth century would be told in photographs, more than in words. Through this unique body of work we can now fully appreciate how his political insight, sophistication, and wit shaped his portrait of John F. Kennedy.

Willis E. Hartshorn
Ehrenkranz Director

CORNELL CAPA AND JOHN F. KENNEDY

Richard Whelan

Among the many thousands of images of John F. Kennedy, one of the most striking barely shows the man at all. Instead, the black-and-white photograph by Cornell Capa shows a placard-waving crowd surging frantically toward JFK as if he were a matinee idol. To get his extraordinary shot of the crowd seen through a closeup of the candidate's remarkably relaxed hands, which members of the crowd were allowed to touch but not shake, Capa had to place himself almost literally in Kennedy's shoes. "JFK was standing on a flatbed truck in the parking lot of a mall," Capa recalls. "I was on the truck, on my knees, using a very wide-angle lens. I was trying to get lower and lower so that I could be on the level of the people's faces. Before I knew it, I was sitting on Kennedy's shoes."[1]

Capa was fascinated by the highly charged ritual of the voter-candidate handshake, and he wanted to zero in on that ritual in the midst of the frenzy. By doing so, he gives the viewer a uniquely intense sensation of what it would feel like to be a man who possessed such extraordinary charisma that people thronged to touch him. In Capa's photograph, the crowd's enthusiastic adulation is so consuming that it almost begins to feel claustrophobic. Such psycho-

logical penetration and sophistication, such sheer intelligence, make Capa's photographs unique in the entire corpus of Kennedy iconography.

It is surely significant that a number of Capa's most memorable photographs of JFK do not show the candidate's face, and yet they very powerfully convey his presence and comment acutely on his role in the political sphere. In one of these photographs, shot in color, Kennedy's head and most of his body are outside the left edge of the frame, though we see the

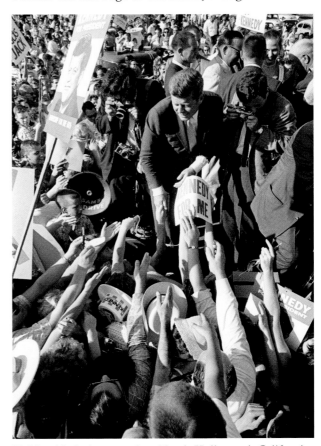

Unidentified photographer, North Hollywood, California, September 9, 1960. The two photographers flanking Kennedy are Cornell Capa (left) and Paul Schutzer.

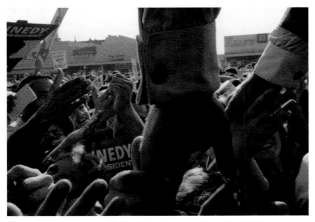

North Hollywood, California, September 9, 1960

shadow of the whole man cast on the auditorium's back wall. The photograph may be taken as a rather philosophical observation about the nature of politics, in which there is always an element of smoke-and-mirrors or, in this case, a projected shadow image which comes to stand for the candidate. Capa's brilliantly realized visual expression of skepticism was, however, certainly aimed at Kennedy specifically as much as at the chicanery of political candidacy in general. When Capa made this picture, during the March-April 1960 Wisconsin primary campaign, he had just met Kennedy for the first time and had a grudge against this young man for upstaging Adlai Stevenson, the elder statesman whose presidential bids in 1952 and 1956 Capa had enthusiastically supported with his camera.

An even blunter and funnier expression of Capa's general distrust of the good faces put on by politicians is his picture of the back of a large freestanding sign in the shape of a candidate's head (possibly Kennedy's); what we see is a blank cutout propped up rather shakily by a couple of two-by-fours—a trenchant comment not only on the thinness of politicians' façades but also on the necessity of political "machines" to back them up.

As Kennedy achieved his party's nomination and then the presidency, Capa's admiration for him grew. One of Capa's most admiring photographs of JFK shows only the top of the president's head, seen from behind, above the back of his chair at a cabinet meeting. Capa, whose work is often leavened by a sense of humor rare in photojournalism, has stated that he intended this picture as a droll comment on the president's youth.[2] Full appreciation of this photograph assumes that the viewer would have a recent memory of Eisenhower's bald head to contrast with Kennedy's abundant head of hair, symbolic of his vigor. At the same time, this image forcefully conveys the power and authority that the office of the president, represented by the monolithic chair, confers upon its occupant.

Although the Budapest-born Capa had moved to New York in 1937, he had shown little interest in American politics until 1952. Then, stationed in London as *Life* magazine's resident photographer, he

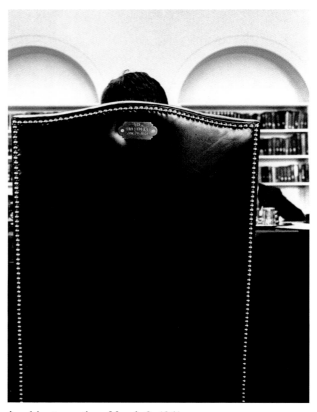

A cabinet meeting, March 2, 1961

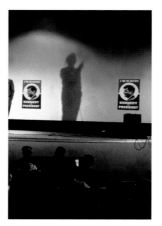

Campaign speech, 1960

Political advertisement, 1960

began to hear radio broadcasts of speeches by Adlai Stevenson, the erudite governor of Illinois. The more Capa heard, the more he desired to return to the

Adlai Stevenson, Libertyville, Illinois, 1952

Adlai Stevenson and Cornell Capa, 1952

United States to cover Stevenson's presidential campaign—if one could call it that, as Stevenson was still undecided about running. The *Life* editors granted Capa's request for a transfer, and he began to work on a profile of Stevenson. "In the spring of 1952," Capa has written, "Adlai Stevenson was still an unfamiliar figure to most Americans. So my first task was to do a story that would give the public a sense of who he really was. What I found was a wonderfully warm, wise, and witty man of high ideals and rare dedication. . . . I was drawn very strongly to all that he stood for and to the man himself as a person."[3] Capa's profile was published in the July 21, 1952, issue of *Life*, under the title "Adlai Stevenson: Democrats' best foot is reluctant to put himself forward." The lead photograph shows Stevenson sitting under a tree on his Illinois farm and, so the caption states, trying to decide whether to run or not. Capa would later say of this picture that he was thinking of Stevenson as very much like the title character in the children's classic *Ferdinand the Bull*, who greatly preferred to smell the flowers in his home meadow rather than to menace matadors in the bullring.[4]

Capa soon followed Stevenson to the Democratic convention in Chicago and became a leading member of the press corps that accompanied the candidate on his campaign travels. No neutral observer, Capa was a passionate Stevenson supporter, and the two men developed a warm friendship. Between the convention and Election Day, *Life* published Capa's photographs in several issues. "The excitement of rallies, his stirring speeches, the camaraderie of our entourage, and the enthusiasm with which he was greeted everywhere only made his defeat on Election Day all the more heartbreaking for all of us," wrote Capa. "We had been exhilarated by Stevenson's magnificent campaign against Eisenhower, the national hero, but Adlai couldn't overcome Ike's winning smile."[5]

By 1956, when Stevenson ran again, Capa had quit *Life* and joined Magnum Photos, the cooperative agency founded in 1947 by photographers Robert Capa (Cornell's older brother), Henri Cartier-Bresson, David Seymour (Chim), George Rodger, and Bill Vandivert. During a brief period after the founding of the upstart photo co-op, *Life*'s editors had been angry about some of its policies but had soon acknowledged that they could not do without the work of Magnum's superlative photojournalists. Within months of the agency's founding, *Life* had become one of its best customers, routinely commissioning Magnum members to shoot major stories. Cornell had been invited to join Magnum at the start, but he felt that he needed to distance himself from his famous brother in order to develop his own very dif-

ferent sort of photojournalistic career. So, he had chosen to remain on the *Life* staff. All that changed drastically after Robert was killed by a landmine in Indochina on May 25, 1954, while on a *Life* assignment. Cornell soon resigned from *Life* and joined Magnum, though the magazine continued to publish many of his photographs.

In January 1956 Capa was engaged by *Life* to accompany a search party as it went into the Ecuadorian jungle to look for a group of American missionaries who had been killed by the Aucas, a

Dallas, Texas, 1961

tribal people whom they had hoped to convert. Capa's photographs of the expedition and of the missionaries' widows had a great impact on *Life*'s editors and subscribers alike. A year later, when Capa returned to Ecuador to document the success that the widows of several of the murdered missionaries were having in being accepted as members of an Auca village, he was strongly attracted to the Aucas' traditional way of life. Struck by the relativism of cultural perceptions, he realized that to an Auca many customs taken for granted in America would appear to be rituals every bit as bizarre as Americans might find those of the Aucas. Consequently, when Capa returned to the United States he embarked on an intermittent four-year project of photographing, mostly in color, what he called "American tribal rituals." The resulting images of groups ranging from football players to Elks are some of his funniest—but also most disturbing—images of American life. Naturally, Capa found

some of the most extravagant tribal rituals in the political arena. His "anthropological" color photographs of politicians and voters are by turns mischievous, debunking, or joyously celebratory of the outlandish behavior of Americans in their political mode.

In 1960, as he set out to cover Stevenson's third attempt to win the presidency, Capa proposed to begin his election-year coverage with a photo-essay shot entirely in color. It was to be an extended visual meditation about the "look" and "feel" of American politics. Capa sold the idea to the editors of *Life*, who assigned Chicago staff correspondent Don Underwood to accompany the photographer on his travels for the story. *Life* bureaus all around the nation recommended upcoming local political events that seemed to promise good material for such a photo-essay. The two-man team crisscrossed the country by air for two or three weeks, following up on what sounded like the best of those suggestions. The extent of their travels is evident in the published story, which includes photographs from Pennsylvania, Michigan, Wisconsin, New Mexico, Maine, Florida, Kansas, and Washington, D.C.

While working on his photo-essay, Capa also covered the Democratic primary campaign in Wisconsin. It was there that he first met the young Senator John F. Kennedy. "I was still very much a Stevenson man," Capa has recalled, "and I resented this upstart senator

Benevolent and Protective Order of the Elks, ca. 1960

with his arrogant slogan that it was now the 'time for greatness.' How dare he? I felt sure that he was a rich boy whose public relations were better than his real potential. And yet I could feel the surge of response that Kennedy evoked from young people, the kind of excitement that Adlai rarely elicited from them. I gradually found myself forced to admit, almost reluctantly, that Stevenson's time was past."[6]

The *Life* editors were so pleased with Capa's color photo-essay that they made it the cover story of the July 4 issue, which was devoted almost entirely to American politics. None of Capa's photographs of Kennedy made it into the published essay, which focused mostly on obscure politicians campaigning for local offices in various parts of the nation. No photograph in the essay shows the face of a national candidate, though the caption of one picture tells us that the hand in it is Richard Nixon's; and Don Underwood recalls that the hand emerging from an elegantly cuff-linked sleeve in another picture is Nelson Rockefeller's.[7]

That this essay grew out of Capa's interest in tribal rituals is confirmed by the text that accompanied it in the magazine, which sought to define the practical rationale and the cultural significance of election-campaign rituals:

The people who practice it call it a game. And it is—superbly fascinating and risky. But politics is much more: a profession, a pathway to power or, in the sweaty and often fumbling working of democracy, the essential step to statesmanship. Cynics practice it; so do idealists. Some of its methods are grubby, some circusy. But mostly they are ritual acts, tested and proved by time. There is only one excuse for baby kissing: it works. The aim, whether the pol is a machine-backed hack or a machine-bucking amateur, is to win the votes.[8]

Capa's spectacular image of a Lansing, Michigan, candidate's nighttime motorcade—illuminated by red flares that made everything look so pink the photograph could have been entitled "Politics Through Rose-Colored Glasses"—was reproduced as a double-width foldout cover. By specifically mentioning the "evocative color photographs" in the essay's brief introductory text, the editors tacitly confirmed how unusual it was to treat a news-related subject other than in black-and-white. The photographs, given a generous ten-page layout, range from the opening picture of a blustery orator standing in front of a Christmas-tree-bulb mosaic of an American flag to the closing spread of a school-gymnasium voting place in Milwaukee dramatically juxtaposed with a shocking image of an angry splatter of red paint on a large poster of a Florida candidate's face.

Capa went to the Democratic National Convention, which began at the Los Angeles Memorial Sports Arena on July 11, with an assignment from *Life* to cover Adlai Stevenson's last-chance bid for the nomination. Once the first ballot decisively knocked Stevenson out of the running, Capa switched his convention coverage to Kennedy, by then the obvious front-runner, to whom *Life* had already assigned a number of its staff photographers. Capa's pictures focus not so much on the candidate himself as on his youthful and high-spirited siblings, in-laws, and their children. He also made some very fine candid portraits of matriarch Rose Kennedy, one of which *Life* used in its July 25 issue along with two of his other black-and-white convention photographs of members of the Kennedy family.

In accordance with longstanding tradition, the presidential election campaigns of 1960 did not officially begin until Labor Day, after the end of Congress's summer session. Although Capa had no lucrative assignment from any magazine, he nevertheless decided to cover some of Kennedy's campaign—and, when the opportunity presented itself, also some of Nixon's. One of his very finest pictures from 1960 is a color shot of a crowd gathered outside a Peoria, Illinois, television station's building to watch a Nixon appearance on a set in a ground-floor window. The levels of illusion and reality in this photograph are absolutely dizzying.

To cover Kennedy's campaign, *Life* had assigned Paul Schutzer, a likeable thirty-year-old staff photog-

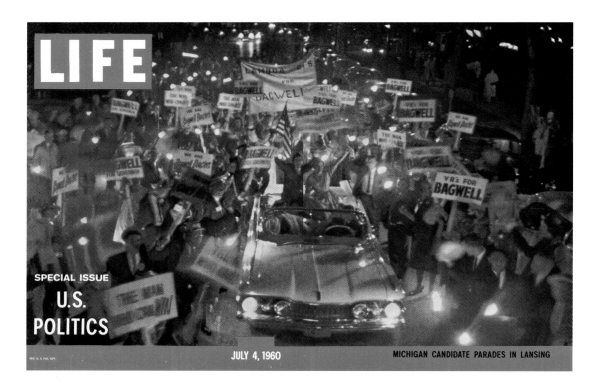

SPECIAL ISSUE
U.S. POLITICS

JULY 4, 1960

MICHIGAN CANDIDATE PARADES IN LANSING

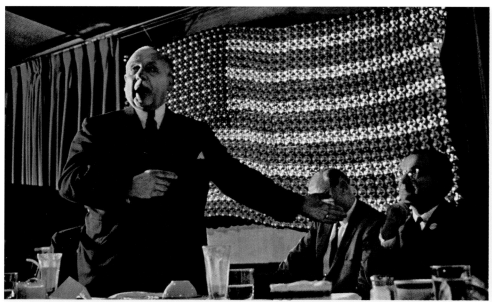

**Timeless gesture
for the man who**

The propelling of a tyro into the arena seems to demand the sweeping gestures and seasoned oratory of an old pro. In this case the beginner, candidate for Congress Herman T. Schneebeli (right), bears fulsome testimony to his many virtues from the practiced throat of George I. Bloom, chairman of the Republican state committee of Pennsylvania. Old Glory, made of Christmas ornaments, adorns the launching.

Politics: A Great Game and a Sight to Behold

The people who practice it call it a game. And it is—superbly fascinating and risky. But politics is much more: a profession, a pathway to power or, in the sweaty and often fumbling working of democracy, the essential step to statesmanship. Cynics practice it; so do idealists. Some of its methods are grubby, some circusy. But mostly they are ritual acts, tested and proved by time. There is only one excuse for baby kissing: it works. The aim, whether the pol is a machine-backed hack or a machine-bucking amateur, is to win the votes.

These honored forms comprise familiar images, a stylized set of tableaux which, if they are clichés, are like no other clichés on earth. On these pages, in evocative color photographs, LIFE has the great honor and privilege to present the unrivaled, inimitable, 100% American look of Politics U.S.A.

Photographed for LIFE by CORNELL CAPA

CONTINUED

Life magazine, July 4, 1960

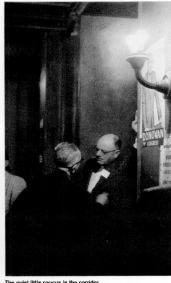

The electorate to be won,

No candidate worth his salt—or a vote—will duck a rally, however sparse the attendance. But the little ones can often be more intimidating than the big ones. These folk, in Argyle, Wis.,

waiting to be convinced

have come to measure a man and plainly are not here to be bamboozled. What's more, they have not yet decided to forgive Jack Kennedy for being 90 minutes late.

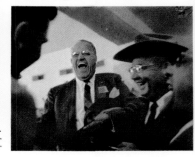

Song to stir things up

Issues are fine and *should* be raised. But it takes more to make a campaign. So the Officeseekers Quartet of Lycoming County, Pa. sings *Stout-Hearted Men* to pep up the place.

A guffaw and a gimmick →

That laugh is intended to win friends for Ingram B. Seven-Foot Pickett. His name (it's legal) is meant to make voters remember to re-elect him New Mexico corporation commissioner.

The quiet little caucus in the corridor

Politicians are forever having a caucus, a kind of huddle whose name seems to stem from the Algonquin Indians. In a formal caucus they may be considering the credentials of delegates or

making an agonizing reappraisal of candidates. Such intimate huddles as this—at Maine's Democratic convention—can give the first hint of changing allegiances and shifts in high strategy.

CONTINUED

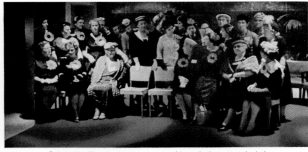

Patient wait to fill out the picture

Both candidates and supporters value a group photograph. There's a sense of hero worship on one side, a reassuring feeling of loyalty on the other. These ladies, whose sunflowers show they come from Kansas, are patient as they wait for a busy Nixon and Pat to complete the picture.

A bracer for the news, good or bad

Campaigning takes its toll right up to the closing of the polls and even after. But there's one good thing: polls closed mean bars open. It was then that campaign workers and friends in Wisconsin repaired to a Milwaukee spot (below) to watch the returns on TV.

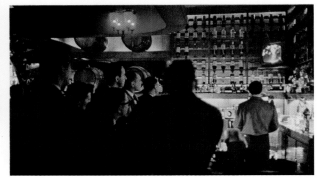

Silver-tongued men of few words who often outlast the listeners

Except for the drops of Spanish moss, this scene could be anywhere in the republic. The fish fry is finished at Wakulla Springs, Fla. and, outlined by the golden glow of floodlights, speakers begin, counting on contented bellies to hold

listeners. Though bucking a three-minute time limit on each, the orators managed to use more than two hours—and watch the voters vanish. The saddest fact to politicians is that speakers love to speak better than people love to listen.

Life magazine, July 4, 1960

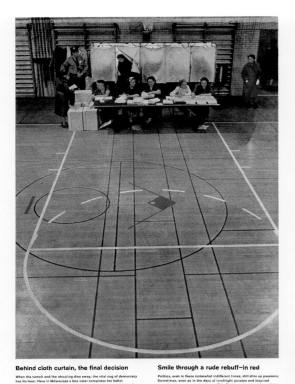

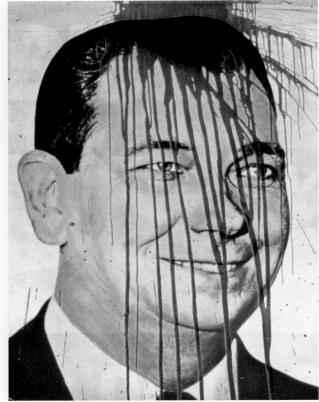

Behind cloth curtain, the final decision
When the tumult and the shouting dies away, the vital cog of democracy has its hour. Here in Milwaukee a late voter completes her ballot as a lone cop stands guard over curtained voting booths, and the poll watchers and election clerks, their vigil ending, can now prepare to count.

Smile through a rude rebuff—in red
Politics, even in these somewhat indifferent times, still stirs up passions. Sometimes, even as in the days of torchlight parades and inspired invective, tempers wax indelicate. This Florida gubernatorial candidate knows, even on a poster, that you can't win 'em all.

Life magazine, July 4, 1960

rapher, to whom JFK granted almost unlimited access. Consequently, Capa was working more or less "on spec," with only a minimal commitment from *Life*. Capa photographed in black-and-white and in color, and his pictures run the gamut from the purely photojournalistic to the humorously anthropological. *Life* got first refusal of each batch of his photographs, since it was by far the best place to publish such work. Anything published in *Life* had a great impact upon an enormous audience. And its huge circulation meant that the editors could pay top fees for whatever they used. Unfortunately for Capa, *Life* was getting so many excellent Kennedy photos from its staff photographers that the editors evidently saw no reason to spend extra money on Capa's. Not a single one of Capa's great photographs of JFK was published in the magazine during the entire 1960 campaign.

Not that *Life* had anything against Capa or his work. On the contrary, Capa was almost universally liked at *Life*. Indeed, the magazine ran a cover story by Capa in the fall of 1960, but it wasn't a political story. It was about Grandma Moses on her one hundredth birthday. Capa's cover photograph was in color. Inside, twelve of his photographs were black-and-white. Only one was in color, together with color reproductions of two of Moses's paintings.[9] During the summer and fall of 1960, *Life* did not reproduce a single color photograph of John F. Kennedy—except for one group shot where he appears with fifteen other people—until a color image of the president-elect appeared on the cover of the November 21 issue.

On Labor Day, September 5, Capa was in Michigan for the official kickoff of JFK's campaign as the Democratic Party's presidential nominee, and the next day he covered Kennedy rallies in Washington State. On the seventh, when both candidates were in

Oregon, Capa photographed Richard and Pat Nixon shaking hands with voters, among them some of the large number of African Americans who remained loyal to Abraham Lincoln's Republican Party.

When a special campaign train headed south for a two-day Kennedy whistle-stop tour through California, Capa was on board. The first day Kennedy engaged in a relentless round of speech-making from the caboose as the train wound south through Dunsmuir, Redding, Red Bluff, Chico, Marysville, Sacramento, Suisun City, Martinez, and Richmond, followed by a major speech that evening in the Oakland Civic Auditorium. At some of the stops Kennedy got off the train to shake hands. One Capa photograph of such an occasion is especially astonishing to a viewer accustomed to today's high security; the candidate is so completely engulfed by the crowd that it is quite difficult to find him in the picture.

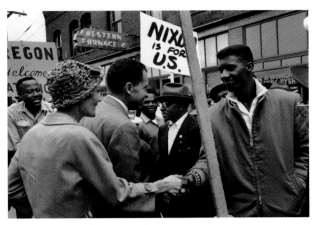

Oregon, September 7, 1960

On September 9 the train made its way south through the San Joaquin Valley, with speeches at Stockton, Modesto, Turlock, Merced, Madera, and Fresno. Then the candidate flew to Tulare and on to Los Angeles. By about five o'clock that afternoon—according to a clock in Capa's photograph of JFK's hands—Kennedy was at the North Hollywood shopping mall rally. In Los Angeles, Capa evidently left the campaign entourage, which continued by plane to Texas.

The rest of Capa's coverage of Kennedy's campaign seems to have been limited to New York City. On October 19 he photographed the candidate and his obviously pregnant wife as they rode in a Chevrolet convertible in what the *New York Times* described as a "tumultuous" ticker-tape parade through downtown Manhattan. The *Times* took special care to describe Jacqueline's stylish outfit as "a three-quarter length off-white cloth coat with a cloche hat to match and white kidskin gloves."[10] The crowds at the intersection of Broadway and Wall Street were so overwhelming that she said, "It felt like the sides of the car were bending."[11]

Eight days later, on October 27, JFK returned to New York, this time without his wife. On that occasion the route of his motorcade passed through Times Square, the garment district, Washington Square, and the Lower East Side before visits to Staten Island, Brooklyn, and Queens. Capa photographed Kennedy in the perennially Democratic

Peoria, Illinois, September 14, 1960

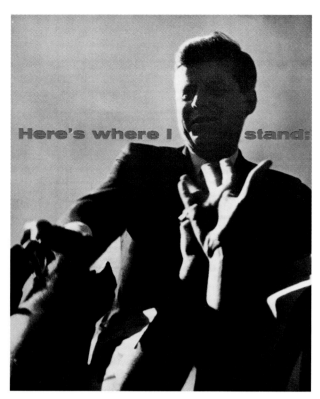

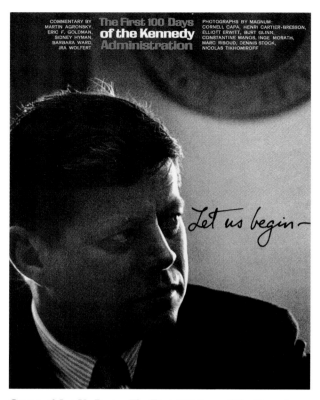

Cover of New York Citizens for Kennedy and Johnson brochure, 1960

Cover of *Let Us Begin: The First 100 Days of the Kennedy Administration*, with portrait of JFK by Cornell Capa

garment district, where a huge crowd enthusiastically hailed the candidate. Capa noted in the margin of one of his prints: "A traditional NY City garment center rally. It is mostly reserved for Liberals and Democrats."

On the evening of Election Day, Capa divided his time between the Democratic Party's New York campaign headquarters in the Biltmore Hotel and the New York Citizens for Kennedy and Johnson dinner at the Astor Hotel. The latter organization, which had been formed by Democrats who opposed New York City's Tammany machine, had used a Capa photograph of JFK with admirers on the cover of one of its brochures to stress Kennedy's connection to the people. At the Biltmore, Capa photographed Tammany boss Carmine De Sapio on the phone, avidly keeping track of the very latest returns and voting trends. Capa had photographed De Sapio at a New York State

Democratic convention in 1954 and described him as "the perfect visual prototype of a machine politician, with his carefully combed wavy hair and his dark glasses, which he wore under all lighting conditions. He was the sinister kingmaker—and looked it."[12]

It was a late night, and in the end Kennedy triumphed over Nixon by only 114,673 votes, one of the closest elections ever. Some claimed it was the Chicago Democratic machine that put Kennedy over the top. "Both campaigns felt somewhat machine-made to me," said Capa. But, he added, "The Kennedy youth and vitality, his performance on the television debates, and, finally, his growing liberalism got me."[13] Swept up in the excitement over the young president-elect, Capa traveled to Washington for his inauguration on January 20, 1961. Greatly impressed by Kennedy's inaugural speech and responding to the "rejuvenating energy of a young, almost visionary,

man in action," Capa decided to do a picture essay on the new administration's young team. [14] After working on his story for ten days, Capa realized "that most conventional—and some not so conventional—approaches to this story would not work."[15] Then, on a plane from New York to Washington, he had a brainstorm. The fact that it had taken *Life* only ten days to publish a booklike "Inaugural Special" brought home to Capa the possibility of producing "a soft-cover, text-and-pictures book while the event is still hot."[16] He was by no means alone in thinking that "the prevailing spirit was like that of 1933, when FDR had brought an adventurous spirit to the White House and had worked miracles during his first one hundred days in office."[17] Why not do a book on Kennedy's first hundred days in office, he asked himself, and have the book published on the 110th day? The book would be called *Let Us Begin: The First 100 Days of the Kennedy Administration*, taking its title from Kennedy's inaugural address, in which he said, "All this will not be finished in the first 100 days. Nor will it be finished in the first 1,000 days, nor in the life of the administration, nor even perhaps in our lifetime on this planet. But let us begin."

As soon as Capa's plane landed, he jumped into a phone booth and called his friend Dick Grossman at Simon & Schuster. Capa said he could get a group of Magnum photographers to cover various challenges facing the new administration at home and abroad, and Grossman could recruit some impressive writer-historians to provide context. Grossman easily sold

Arthur M. Schlesinger, Jr., 1961

the idea to his firm, which set up an office in Washington especially to coordinate editing of the photographs and texts. Kennedy himself was not at all enthusiastic about the project—which would reinforce unwelcome comparisons with FDR's fantastic accomplishments—but his press secretary, Pierre Salinger, successfully argued that such prestigious and sympathetic coverage was not to be passed up.

Capa's own assignment was the White House itself, photographing not only President Kennedy but also key members of his staff—such as Pierre Salinger, special counsel Theodore C. Sorensen, appointments secretary Kenneth O'Donnell, congressional liaison Lawrence O'Brien, and special assistants McGeorge Bundy and Arthur M. Schlesinger, Jr.—in their offices and as they went about their duties. And, of course, Capa was in the corps of photographers covering all of the major events: Kennedy's first press conference, on January 25 (the first presidential press conference ever to be televised live); the first cabinet meeting, on January 26; and the first State of the Union address to Congress, on January 30.

Capa scored a real coup on February 2, when the cabinet had its second meeting of the administration.

Theodore C. Sorensen, 1961

He and *Life*'s Alfred Eisenstaedt became (if the information given them at the time was correct) the first photographers ever to document any president's cabinet in session. Under the watchful eyes of Abraham Lincoln, whose portrait had replaced Jefferson's only a few days earlier, Capa made some of his finest portraits of Kennedy, focusing in particular on his decisive gestures and firm gaze.

Capa scored a different kind of a coup one afternoon in early March. "I was hanging around in the secretaries' room at the White House," recalled Capa, "when I looked out the window and saw Jackie, outside on the snow-speckled grounds, pushing three-month-old John-John in his carriage."[18] He grabbed a camera with a telephoto lens and snapped what has become a classic image of the legendary first lady, enjoying a rare moment alone with her baby, as happy and proud as any other young mother.

Later that month Capa photographed two events related to the growth of U.S. involvement in Southeast Asia, which would prove to be the most terrible legacy of the Kennedy administration. One of these events, on March 23, was the president's televised press conference in which he declared that the United States was committed to the support of General Phoumi, the de facto ruler of Laos, in his fight against procommunist rebels. As Kennedy pointed to a large map of the region, he announced that the U.S. would, if necessary, intervene militarily, and he called upon America's allies for assistance in such a move. Four days after the press conference, seeking assurances that Soviet Premier Nikita Khrushchev would not intervene, he invited Soviet Foreign Minister Andrei Gromyko for a stroll in the White House rose garden to discuss the situation. After their private conversation—which led to Khrushchev's promise of neutrality in Laos—Capa photographed the two men seated at Kennedy's desk in the Oval Office.

Neither delayed nor deterred by events, *Let Us Begin* was published right on schedule, on the 110th day of the administration. The book contains photographs by Capa and eight other Magnum photographers (two of whom also contributed brief texts) as well as essays by six distinguished historians and journalists. Capa's images, made in the White House and in the Capitol, were used to illustrate a long essay by Eric F. Goldman entitled "New Generation." (There are also, at the back of the book, two pages of Capa's portraits of White House officials.) The second section of *Let Us Begin* is titled "The World's New Frontiers." It includes Inge Morath's photographs of the United Nations headquarters, with an essay by Barbara Ward of the *Economist*; a report by Marc

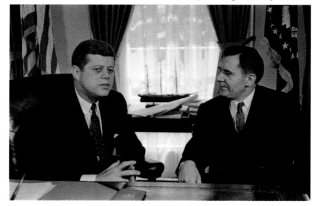

President Kennedy and Soviet Foreign Minister Andrei Gromyko, The Oval Office, March 27, 1961

Riboud about famine in the Congo; a story about a water crisis in Ecuador by Constantine Manos; and images of war-torn Laos by Nicholas Tikhomiroff. The third section, devoted to civil rights, pairs photographs by Henri Cartier-Bresson with an essay by Wallace Westfeldt, Jr. The final section, on the economy, includes an essay on poverty by Ira Wolfert accompanied by photographs by Burt Glinn, Constantine Manos, and Elliott Erwitt. What was to have been the final essay was written jointly by Sidney Hyman and Martin Agronsky and illustrated with photographs by Dennis Stock. However, on the eighty-sixth day, April 15, the beginning of the disastrous Bay of Pigs invasion forced the editors to commission a short text from Barbara Ward to set that fiasco in some perspective.

The book's timing was unfortunate for its critical reception. Kennedy's handling of the crises in Cuba and Laos had deeply disappointed and disillusioned many of his erstwhile admirers, both in the United States and around the world, and the reaction of the press to the book reflected that fact. A lukewarm review in *Time,* under the title "Instant History," criticized the book for devoting so little attention to Cuba and Laos,[19] and pundit Richard Rovere's pan in the *New York Times Book Review* cited bad printing and other shortcomings.[20] The most thoughtful and balanced review appeared in the *New York Herald Tribune,* where David Wise wrote that the book "attempts a difficult task: to hold a mirror up to the frighteningly complex world with which John F. Kennedy and the hard-working young men he has brought to Washington must reckon. That the image is fast-changing, kaleidoscopic, and perilous is nowhere better illustrated than by the fact that although the subtitle of this volume is the first 100 days of the Kennedy administration, it was largely prepared during the first eighty-six days of the Kennedy administration—before Cuba. And the last fourteen days of the first 100 colored all that went before."[21] Despite the mixed reviews, this timely and revealing book sold nearly 150,000 copies, suggesting that the American public was eager for images and analysis of the new Kennedy administration.

Capa did not stop photographing President Kennedy at the end of his first hundred days. In June he traveled to Paris to cover the presidential visit, during which the francophile First Lady so thoroughly stole the show that JFK began one press conference with the quip: "I do not think it altogether inappropriate to introduce myself to this audience. I am the man who accompanied Jacqueline Kennedy to Paris, and I have enjoyed it."[22] Perhaps no photographs depict the Kennedys as American royalty more clearly than do Capa's of the state dinner at Versailles. (A headline in the next evening's edition of *France-Soir* proclaimed, "Versailles has a queen at last."[23]) Then Capa followed the presidential entourage to Vienna for a summit meeting with Khrushchev. Some of the most revealing insights regarding that historic event are to be found in Capa's photographs of the gestures that Kennedy and Khrushchev made during their face-to-face encounters, in his picture of Mrs. Khrushchev's back as she takes in the splendors of the Pallavicini Palace, and in his image of Jacqueline Kennedy utterly charming the formidable Soviet tyrant during a state dinner at the Schönbrunn Palace. That scene led the *Washington Post* to comment that the first lady's European triumph was so complete that it "included even Soviet Premier Nikita Khrushchev."[24] Although Khrushchev was more impressed by the youthful president than he expected to be, and was surprised by the composure with which he held his ground in the face of relentless bullying, the Soviet leader judged Kennedy as lacking the nerve for nuclear brinksmanship. That estimation led, just over two months later, beginning on August 13, to the construction of the Berlin Wall, about which Khrushchev correctly assumed that Kennedy would do nothing but protest. Such confirmation of the opinion he had formed in Vienna soon led Khrushchev to begin sending nuclear missiles to Cuba.

That European trip concluded Capa's photographing of John F. Kennedy, but it by no means ended his coverage of American politics. During the early 1960s he spent quite a lot of time photographing Nelson Rockefeller, and in 1964 he did a major story for *Look* magazine about the presidential campaign of

Arizona archconservative Barry Goldwater. For his last big political story he photographed Hubert Humphrey at the 1968 Democratic National Convention in Chicago. Although Capa continued to bring to his coverage of politics the same profound levels of insight, humor, and photographic virtuosity that he achieved in 1960, only one of the candidates he photographed during the rest of the decade had anything approaching JFK's charisma and extreme photogenic quality: Robert Kennedy. Capa covered a thrilling day early in his successful 1964 bid for one of New York's seats in the United States Senate. As fine as those pictures are, however, they do not have the powerful visual magic that had been produced when Capa encountered John F. Kennedy, who was, without a doubt, his greatest subject.

ACKNOWLEDGMENTS

My very warmest thanks go to Kristen Lubben, Assistant Curator at ICP, who worked with me as co-editor of this book and co-curator of the exhibition which it accompanies. Working with her has been a great pleasure, and she has contributed immeasurably to every aspect of the exhibition and book, including my introductory essay.

Ms. Lubben and I wish to thank all of the many members of the ICP staff who have aided us in the preparation of exhibition and book, especially Chief Curator Brian Wallis (who first came up with the idea for this project), Publications Manager Karen Hansgen, Assistant Curator Cynthia Young, and Curatorial Assistant Erin Barnett.

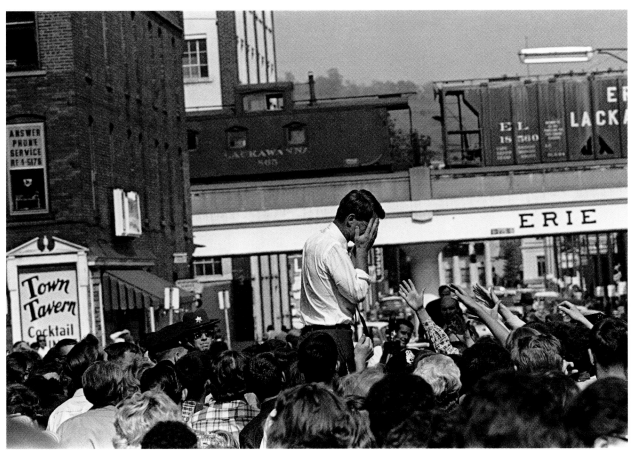

Robert F. Kennedy, Buffalo, New York, September 8, 1964

We also wish to express our gratitude to a number of persons who provided crucial information for my essay and for the captions: Arnold Sagalyn; Theodore C. Sorensen and his assistant Laurie Vargas; Philip Kunhardt, Jr.; Don Underwood; John Morris; Fred Holborn; Myer Feldman. James B. Hill, audiovisual Archive Specialist of the John F. Kennedy Memorial Library patiently and expertly answered innumerable questions about factual details.

I want to give special thanks to my friend Evan Cornog, who graciously allowed us to reprint his essay about the 1960 campaign, which he originally wrote for the book *Hats in the Ring: An Illustrated History of American Presidential Campaigns*, of which he is the author and I the picture editor.

Above all, I want to express my most profound gratitude to Cornell Capa for the privilege and the pleasure of working closely with him for more than twenty-five years—and until her death in November 2001, with his wife, Edie. Cornell and Edie have been among the very most important and inspiring people in my life. I hate to think of what my life might have been without their love, without the opportunities they gave me, without the doors they opened for me around the world, and without all of the wonderful people I have come to know through them.

1 Cornell Capa and Richard Whelan, eds. *Cornell Capa: Photographs.* Boston: Bulfinch/Little Brown; 1992, p. 209.
2 In conversation with the author.
3 Capa and Whelan, *op. cit.*, p. 86.
4 In conversation with the author.
5 Capa and Whelan, *op. cit.*, p. 86.
6 *ibid.*
7 In conversation with the author.
8 *Life*, July 4, 1960, p. 13.
9 *Life*, September 19, 1960, pp. 104-112.
10 *New York Times*, October 20, 1960, p.25.
11 *ibid*, p.1.
12 Capa and Whelan, *op. cit.*, p. 209.
13 Cornell Capa memo to Richard Grossman, undated [February 1961]. Capa Archives, ICP.
14 *ibid.*
15 *ibid.*
16 *ibid.*
17 Capa and Whelan, *op. cit.*, p. 86.
18 *Ibid*, p. 209.
19 *Time*, June 16, 1961, p. 90.
20 *New York Times Book Review*, June 4, 1961, p.18.
21 *New York Herald Tribune Book Review*, May 21, 1961, p.25.
22 President John F. Kennedy, remarks at press luncheon, Paris, June 2, 1961.
23 *France-Soir*, June 2, 1961.
24 *Washington Post*, June 4, 1961.

Richard Whelan, an independant cultural historian who specializes in the history of photography, is adjunct curator of the Robert Capa and Cornell Capa Archives at the International Center of Photography. Among his twenty published books are acclaimed biographies of Robert Capa and Alfred Stieglitz. He co-edited, with the photographer, *Cornell Capa: Photographs* (1992)

SELECTED BIBLIOGRAPHY

Capa, Cornell, and Richard Whelan, eds. *Cornell Capa: Photographs.* Boston: Bulfinch/Little, Brown, 1992.

Cornog, Evan, and Richard Whelan. *Hats in the Ring: An Illustrated History of American Presidential Campaigns.* New York: Random House, 2000.

Dherbier, Yann-Brice, and Pierre-Henri Verlhac. *John Fitzgerald Kennedy: A Life in Pictures.* London & New York: Phaidon, 2003.

Kunhardt, Philip B, Jr. Life *in Camelot: The Kennedy Years.* Boston: Little, Brown, 1988.

Lowe, Jacques. *Remembering JFK: Intimate and Unseen Photographs of the Kennedys.* New York: Arcade, 2003.

Lubin, David M. *Shooting Kennedy: JFK and the Culture of Images.* Berkeley: University of California Press, 2003.

Salinger, Pierre. *With Kennedy.* Garden City, NY: Doubleday, 1966.

Schlesinger, Arthur M., Jr. *A Thousand Days: John F. Kennedy in the White House.* Boston: Houghton Mifflin, 1965.

Sorensen, Theodore C. *Kennedy.* New York: Harper & Row, 1965.

White, Theodore H. *The Making of the President, 1960.* New York: Atheneum, 1961.

THE 1960 CAMPAIGN

Evan Cornog

The Kennedy-Nixon contest of 1960 has become so freighted with symbols, so laden with signs of the tumultuous decade that followed, and so emblematic of the emergence of the televised presidential campaign that we must remind ourselves that it was also one of the closest elections in American history. Nixon's biographer Stephen Ambrose has observed that with a few breaks in his direction we would be congratulating him on "staying away from the religious issue" (of Kennedy's Roman Catholicism), "admiring his good political sense in saving Ike until the last minute," and generally dismissing incidents, such as Kennedy's superior performance in the first of their four televised debates, that now seem central. While the keepers of the Kennedy flame have at times portrayed the election in almost Manichean terms, Camelot versus Golgotha in prime time, the closeness of the contest has caused some historians to focus on the small events that might have tipped the victory the other way. Historians and political scientists fond of statistical analyses have shown that being Catholic cost Kennedy votes—and that his religion helped him win. More than anything, this race was a confrontation between two supremely ambitious, ruthless men who fought tenaciously, and on the whole fairly, for the right to succeed Dwight D. Eisenhower as President.

Ike's shadow loomed over the contest at the time and still affects the way it is viewed. Because Eisenhower had won two presidential races by large margins and because Nixon was in second place on the ticket in those two wins, Kennedy's triumph in 1960 is often seen as a difficult feat, if not a stunning upset. But as Kennedy's aide Theodore C. Sorensen noted in a memo in August 1960, the Democrats were the majority party in the country, and given a good campaign Kennedy should win. (The wild card for Sorensen was religion, and he felt that Kennedy would have to respond effectively to this to ensure his victory.) Eisenhower's lack of enthusiasm for his Vice President was fairly obvious, as had been shown in 1952, when he had refused to help Nixon extract himself from his "secret fund" scandal, and in 1956, when he had allowed Harold Stassen to foment a dump-Nixon movement. In August 1960, with Nixon the nominee of his party, Ike was asked in a press conference what policy ideas Nixon had contributed to the administration. "If you give me a week, I might think of one," the President said, "I don't remember."

In 1956, Eisenhower had been able to run on a platform of peace and prosperity, but his second term had been rough. The fall of 1957 had seen two major crises. The first had concerned school desegregation in Little Rock, Arkansas, where an unwilling Ike had had to call in army troops and nationalize the Arkansas National Guard to protect black students. Orval Faubus, the governor of the state, was attempting to build his popularity by blocking school integration and brazenly appealing to racist sentiment. Although Eisenhower had no wish to hasten desegregation, Faubus's challenge to his authority was overt, and he felt he had to act.

The second crisis had come in early October, when the Soviet Union had launched the first man-made satellite to orbit the Earth, *Sputnik*. This triumph of Russian rocket engineers punctured America's assumption of scientific superiority and led to worries, exploited by Kennedy in the 1960 campaign, that there was a "missile gap" that the United States desperately needed to close if it was to remain secure. Also, by the end of 1957 and on into 1958, the economy was in recession, and this helped the Democrats make substantial gains in the midterm congressional elections, increasing their majorities in both the House and the Senate. The only bright spots for the Republicans came with the election of a new

governor of New York, Nelson Rockefeller, and a strong re-election effort by Arizona senator Barry Goldwater.

Both parties were turning to a new generation of leaders, men (only men were considered presidential timber) who had fought in the Second World War but had not been, like Ike, in positions of great responsibility. The leading Democratic hopefuls all came from the Senate. The majority leader, Lyndon Johnson of Texas, was respected and feared by his colleagues and had done a capable job of managing legislation, helping achieve the compromise that had led to the passage of the Civil Rights Act of 1957, the first such piece of legislation since Reconstruction. But

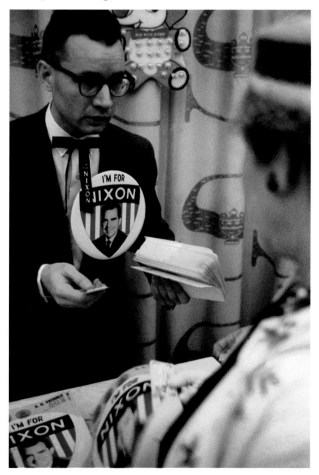

Nixon supporter, 1960

Johnson was from the South, and this was still considered a drawback to winning. Hubert Humphrey of Minnesota was the most liberal candidate in the race but was perennially short of funds. John F. Kennedy, who had been given a huge victory by Massachusetts voters when he ran for re-election in 1958, had shown heroism as a PT boat captain in the Pacific war and in 1957 had won a Pulitzer Prize for his set of essays on American history, *Profiles in Courage.* Missouri's Stuart Symington was an expert in defense matters and had the support of Harry Truman. Also available, but not actively running, was Adlai Stevenson, twice the loser to Eisenhower but still with a large following.

Although primary elections were becoming more important, many delegates were still chosen by party insiders rather than voters, and both Johnson and Symington were resting their chances on their connections within the party. Kennedy and Humphrey had no hope except by contesting primaries, and it was the matchups between the two in Wisconsin and West Virginia that decided the nomination. Wisconsin was adjacent to Humphrey's home state of Minnesota and also had a large Catholic population, and Kennedy knew that a victory there would help establish him as a candidate who could appeal across the nation. He spent much of the month of March in Wisconsin, shaking hands, meeting voters, honing his campaign form. All this paid off, and his winning in Wisconsin brought attention to his campaign. The next major battleground was West Virginia, where the salience of Kennedy's Catholicism as a campaign issue would be tested. Humphrey made it clear that he would not use the issue against Kennedy; in fact, he said he would not want anyone to vote for him because of concern over Kennedy's religion. But Humphrey's campaign was poor, and Kennedy had a rich father to bankroll his effort; easily outspending Humphrey, Kennedy also beat him easily, and Humphrey withdrew from the race.

Still, Kennedy arrived at the Democratic convention in Los Angeles uncertain if he had enough votes to win, and there was the chance that if he didn't win on the first ballot, delegates would bolt to another

Richard Nixon, 1960

candidate, such as Stevenson or Johnson. On the eve of the convention, Johnson's campaign leaked the news that Kennedy had Addison's disease, an adrenal condition, and was receiving daily cortisone treatments. Kennedy's aides denied the story (they lied), and the issue was passed over, in part because Kennedy looked so healthy and his publicists stressed his outdoor lifestyle. When the balloting took place, the outcome was not certain until the final state in the roll call, Wyoming, put Kennedy over the top, with 806 votes; Johnson was second, with 409. Then Kennedy asked the Texan to accept the second spot on the ticket, and Johnson, to general amazement, did.

Two weeks later, the Republicans met in Chicago to nominate Richard Nixon. Any other possibility had long been foreclosed, and the meeting was a carefully scripted celebration of Eisenhower and Nixon. For his running mate, Nixon chose Henry Cabot Lodge, the former Massachusetts senator (he had been defeated by Kennedy in 1952), who had been appointed by Eisenhower to represent America at the United Nations. Although a respected man, Lodge could hardly have been expected to bring much to the ticket, since Kennedy's strength in New England was unassailable. And Lodge proved to be a reluctant campaigner, unlike Johnson, who carried the Democratic message throughout the South.

However different from each other Kennedy and Nixon look to us today, at the time many saw tremendous similarities: both were young men (JFK was forty-three, Nixon forty-seven) practiced in the arts of politics and unhindered by discernible principles. If Eisenhower had trouble recalling Nixon's contributions in the White House, so Kennedy's colleagues on Capitol Hill had trouble recalling what he had done there. "The Processed Politician has finally arrived," the veteran newsman Eric Sevareid commented.

For the Processed Politician the testing ground would be television, in a series of four debates beginning in late September. But before Richard Nixon got to the debates, he had some bad luck. He banged his knee on a car door in August and finally, after

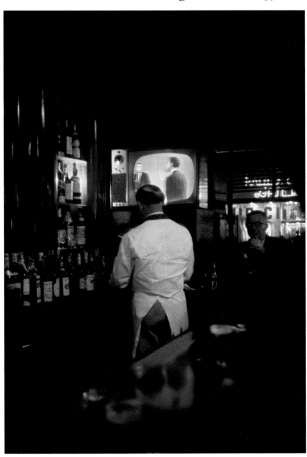

The fourth and last of the Kennedy-Nixon debates (held in New York City on October 21, 1960), as seen on the television of a New York bar

ignoring the pain for some time, consulted a doctor. He was told that he would have to spend two weeks in the hospital to fight a serious infection. So at the beginning of September, as the race was beginning, Nixon had to lie on his back and watch Kennedy get a head start. Nixon lost ten pounds and, stubbornly refusing to deviate from a pledge to make campaign appearances in all fifty states, he pushed himself even harder than usual when he was well enough to resume campaigning, in mid-September.

The first debate took place in Chicago on September 26. Nixon was tired and underweight, and he banged his ailing knee again getting out of the car at the studio. Kennedy, who had been campaigning in California, spent the afternoon tanning himself and came to the studio looking fit and rested. Nixon refused to have any but the most rudimentary make-up, and the heat of the lights, combined with his poor condition and the pain in his knee, turned him into a sweaty, hollow-eyed, pasty, and nervous adversary for the calm, handsome Kennedy. Ike had told Nixon that he should not debate Kennedy: Nixon was better known and would inevitably lose ground simply by appearing on equal terms with his opponent. Nixon, however, felt that he had to meet the challenge and was confident that his command of facts would be crucial. But images, not facts, were what mattered. Those listening on the radio thought Nixon won the first contest, but television viewers—around 70 million of them, attracted by this new phenomenon of American politics—gave the advantage to Kennedy. Henry Cabot Lodge's reaction was to the point: "That son-of-a-bitch just lost us the election."

That explanation, however appealing, is not sufficient. Nixon, after all, was a canny politician with many resources to draw on, and a misstep in late September was hardly conclusive, particularly since his entire strategy rested upon a crescendo of appearances and announcements in the last few weeks of the campaign. That was when he intended to use Eisenhower, who was not enthusiastic but was willing to do what he could (given his poor health) for the GOP. And that was when, Nixon hoped, some dramatic event in foreign affairs might swing voters his

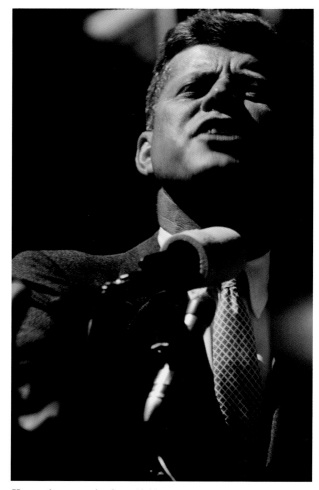

Kennedy campaigning, 1960

way. The year before, Cuba had come under the control of Fidel Castro, who had drawn close to the Soviet Union and was nationalizing American holdings in Cuba. Nixon advocated a military strike against Castro's regime, but Eisenhower decided that the time was not right. Then, after Kennedy proposed the sort of military adventure that Nixon was hoping for, Nixon was put in the unpleasant position of having to defend the administration's inaction.

Surprisingly, given Nixon's reputation as a dirty campaigner, he avoided using Kennedy's Catholicism as an issue. Others tried to use it for him, and Kennedy decided to face the issue head-on by addressing a group of Protestant divines in Houston on

September 12. He was eloquent, telling his listeners, "If this election is decided on the basis that 40,000,000 Americans lost their chance of being President on the day they were baptized, then it is the whole nation that will be the loser in the eyes of Catholics and non-Catholics around the world, in the eyes of history, and in the eyes of our own people." From a tape of the performance, Kennedy's aides made various short spots and a long version and broadcast them in selected markets around the nation. They also made use of clips from the first debate, so that their candidate's best moments and Nixon's worst ones were kept in the public eye. The Democratic campaign had to go into debt to make the ads and broadcast them, but it was willing to take the risk (as were its suppliers, at least one of whom was never paid).

The three other debates were more even, but fewer people watched. Kennedy had already gained a decisive advantage in the first contest, for now that he had won a face-to-face contest, his less impressive credentials no longer seemed as important. Nixon's people learned their lesson from the first encounter, and at the second debate Nixon submitted to a full regime of makeup. (His aides lowered the thermostat in the building where the debate was being held; Kennedy's aides then sneaked out and raised it.)

Nixon had more bad luck. On October 25, just as he was launching his final offensive, Dr. Martin Luther King, Jr., was sentenced to four months in jail as a consequence of a minor traffic infraction. John Kennedy called King's wife, Coretta, to offer his support, while Robert Kennedy, without consulting his brother, called the judge in the case and persuaded him to free King on bail. Nineteen sixty was a year of increasing activism among Southern blacks, with lunch counter sit-ins by college students drawing international attention. Both parties had similar civil rights approaches: they endorsed the principles of equal rights and opportunity and avoided any more concrete commitment as much as possible. In this atmosphere, Kennedy's phone call, small gesture though it was, attracted a lot of attention in black

America. Reverend King's father said he had "a suitcase of votes" and that he would take them to JFK and "dump them in his lap," and the Sunday before the election Democratic workers distributed pro-Kennedy literature in black churches across the nation. African American voters supported Kennedy in much greater numbers than they had Stevenson four years earlier.

If one looks at the campaign as a whole, the safest conclusion to be drawn is that issues mattered little. Kennedy and Nixon both ran as Cold Warriors, the only question being which candidate was truer to the cause. Kennedy's call to Coretta King was about the only thing he did to signal his support for civil rights, and Lyndon Johnson, campaigning for the ticket in the South, routinely mentioned his family's Confederate roots to appeal to white voters there.

On the final weekend, it was clear that the election would be very close. Nixon, however, had still not set foot in his fiftieth state, Alaska, and he spent valuable time fulfilling his pledge rather than visiting states such as Illinois, where the race was close and many more electoral votes were at stake.

Kennedy's popular-vote margin was thin—119,450 votes out of more than 68.8 million cast. His electoral-vote margin was 303 to 219, with 15 electors casting votes for the Dixiecrat Harry F. Byrd of Virginia, whose noncampaign had attracted about half a million segregationist voters. The question of what had made the difference—Nixon's performance at the first debate, Kennedy's call to Mrs. King, or the Democratic majority nationwide, which reflected the continuing strength of Roosevelt's New Deal coalition—is impossible to answer, just as it is impossible to be certain whether Kennedy's Roman Catholicism helped bring Catholic voters to the polls for the Democrats or energized anti-Catholic Protestants to vote for Nixon.

But the campaign did change the face of American politics and made it clear that the place to be was not on a whistle-stop tour or in a union hall but on TV. As the political process evolved over the next few decades, the place of television grew in importance.

Politics was emerging from smoke-filled rooms, conventions were changing from places where choices were made to places where choices were ratified, and substance was losing ground to image. Above all, candidates now needed to find huge amounts of money to buy television time in order to present their painstakingly selected and tested messages to the American public.

This essay was first published in Evan Cornog and Richard Whelan, *Hats in the Ring: An Illustrated History of American Presidential Campaigns*, Random House: New York, 2000, and appears here courtesy of Random House and the author.

Evan Cornog is the author of *The Birth of Empire: DeWitt Clinton and the American Experience*, 1769–1828 and *Hats in the Ring: An Illustrated History of American Presidential Campaigns*. He is currently an associate dean at Columbia University's Graduate School of Journalism. He lives in New York City.

The Color of Politics

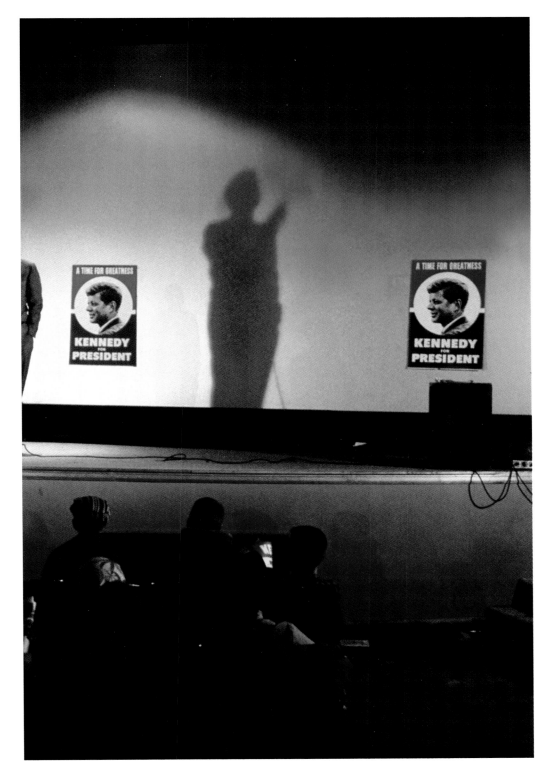

Campaign speech, 1960
Throughout 1960, Capa traveled the country taking color photographs of politicians for a July 4 issue of *Life*. The published photo-essay "A Great Game and A Sight to Behold," focused on the eccentric traditions and trappings of politics rather than any specific candidate, though many of Capa's great color photographs of Kennedy were taken in the course of working on this story.

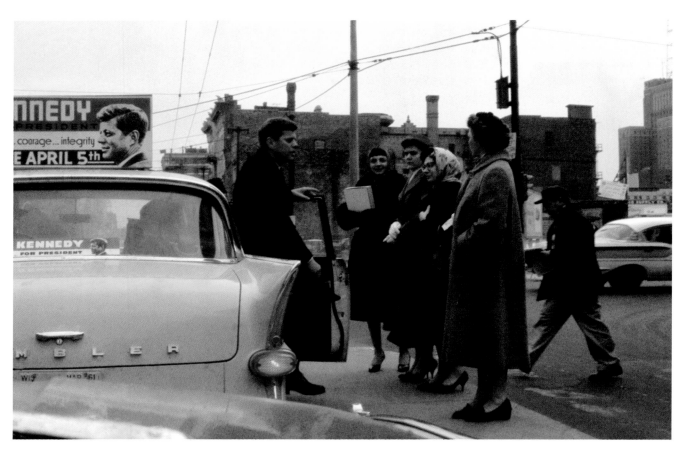

Campaigning in Wisconsin before the April 5th primary, 1960
Capa first encountered Kennedy while covering the Democratic Primary in Wisconsin.

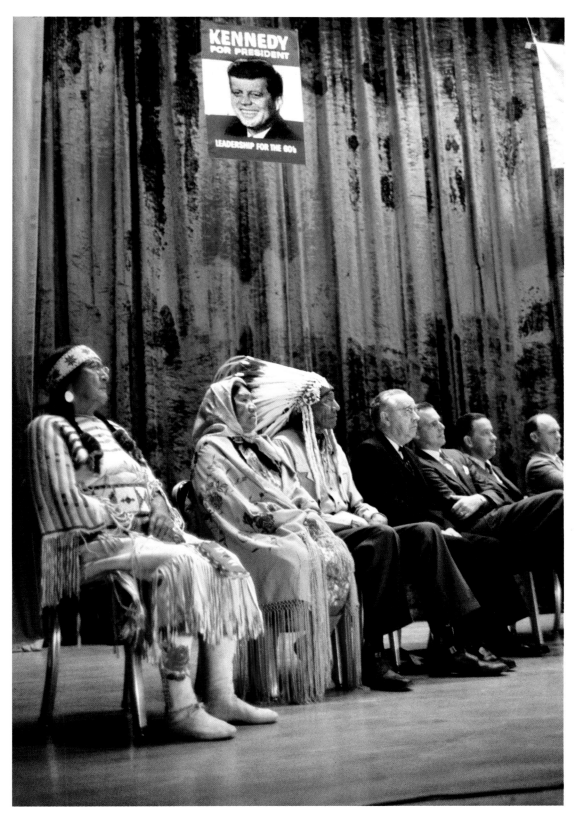

Henry "Scoop" Jackson, chairman of the Democratic National Committee (fourth from right), and Native American Kennedy supporters, 1960

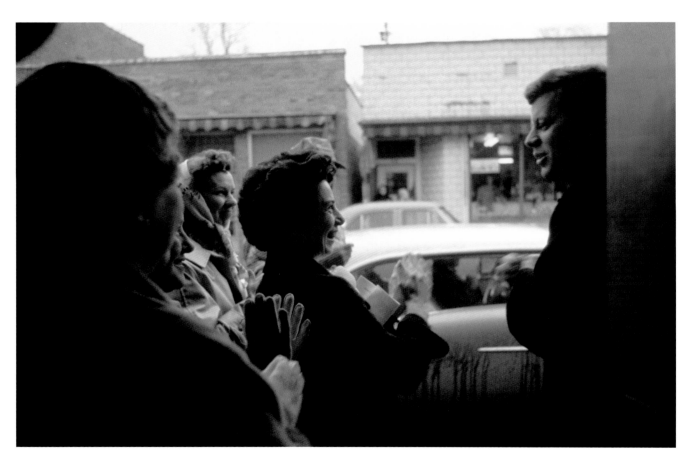

On the campaign trail, 1960

On the campaign trail, 1960

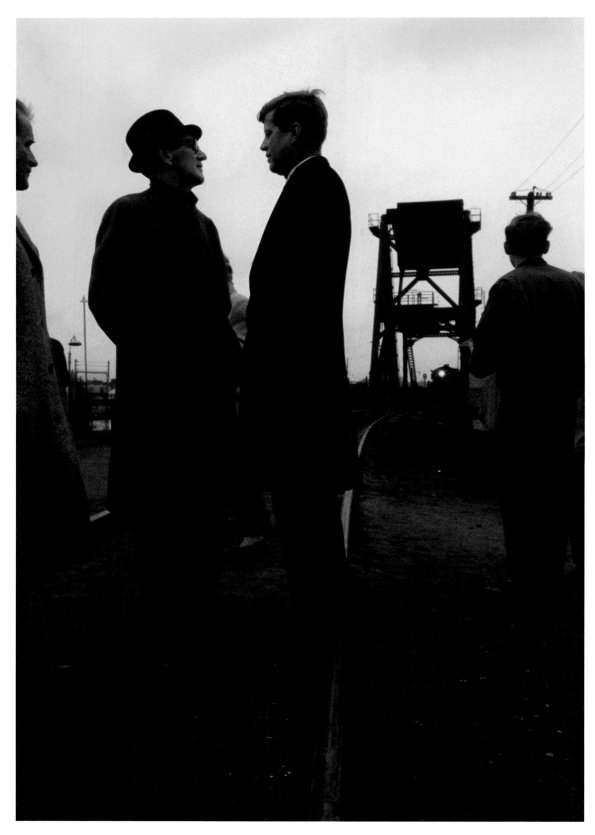

On the campaign trail, 1960

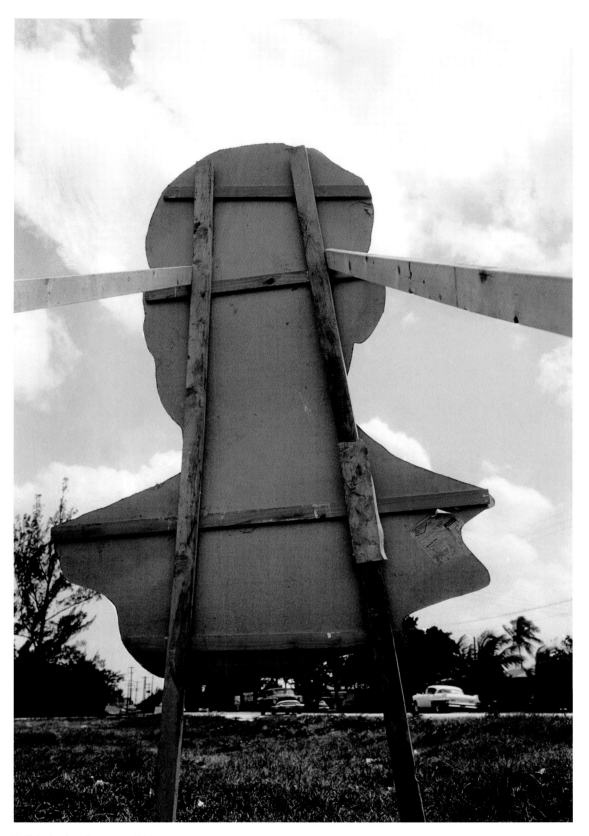

Political advertisement, 1960

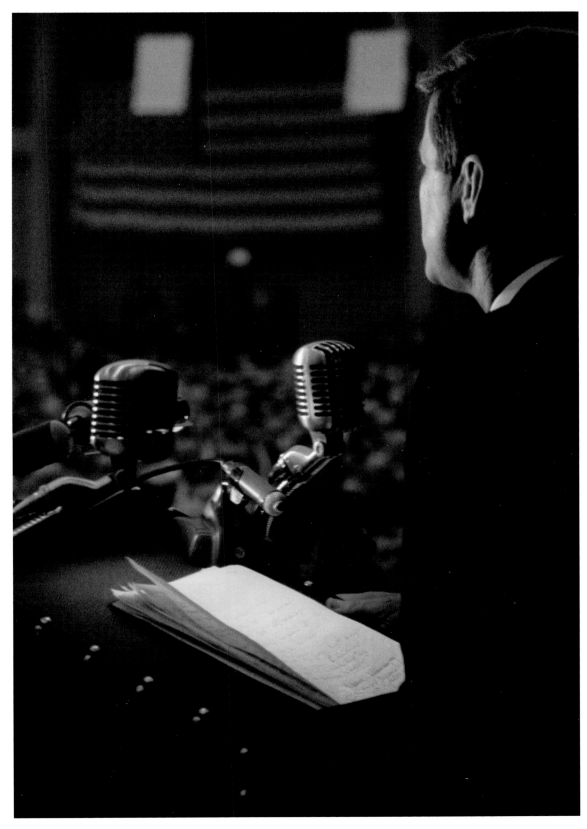

Campaign speech, 1960

The Convention

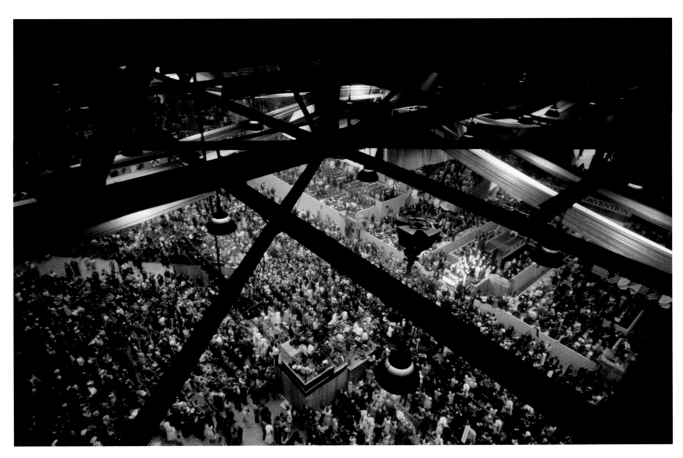

The Los Angeles Memorial Sports Arena, site of the Democratic National Convention, July 11–15, 1960

Kennedy's sister Patricia Lawford, sisters-in-law Ethel Kennedy and Joan Kennedy, and family friend K. Lemoyne (Lem) Billings, July 14, 1960

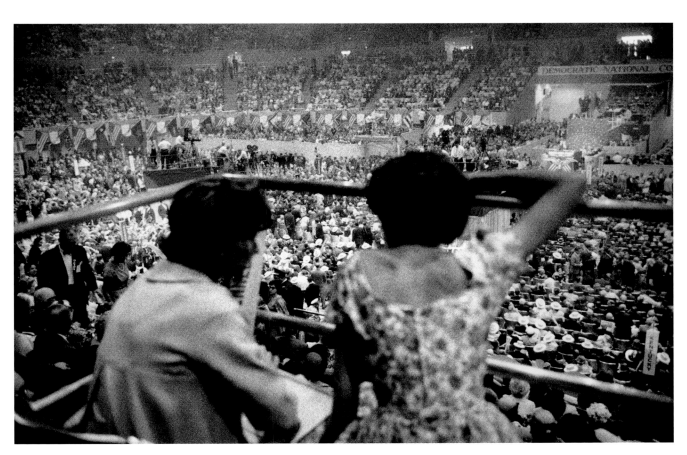

Jean Smith and Eunice Shriver, two of Kennedy's sisters, July 14, 1960

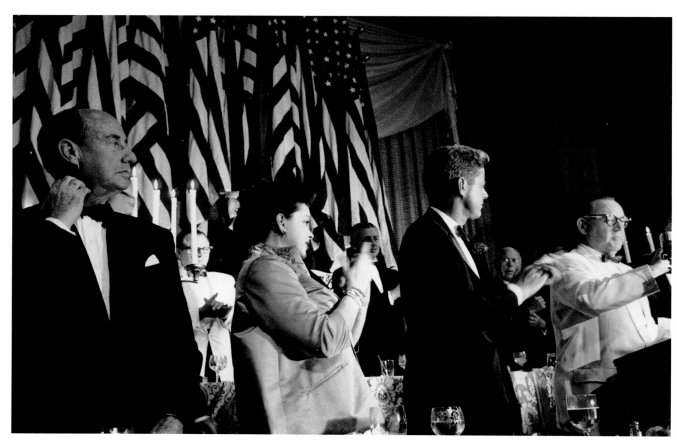

Adlai Stevenson, Judy Garland, John F. Kennedy, and California Governor Edmund G. ("Pat") Brown at the Democratic National Convention, July 12, 1960

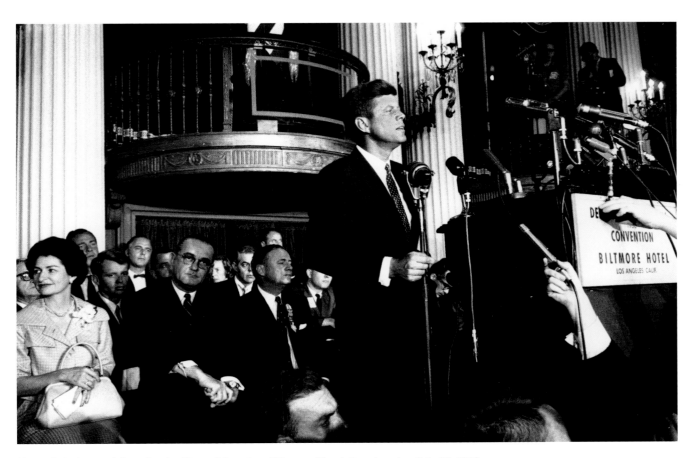

Kennedy-Johnson debate for the Texas delegation, Biltmore Hotel, Los Angeles, July 12, 1960

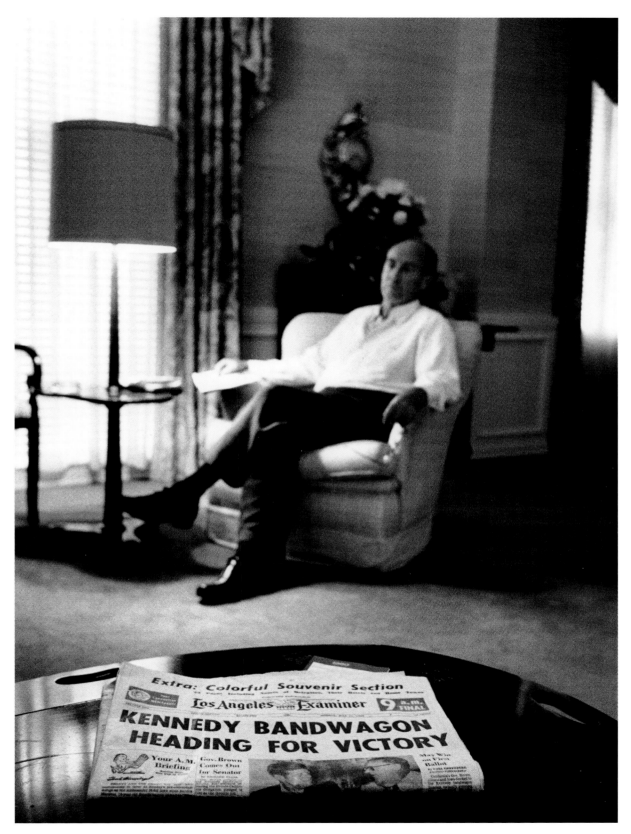

Adlai Stevenson in his hotel room, Democratic National Convention, July 11, 1960

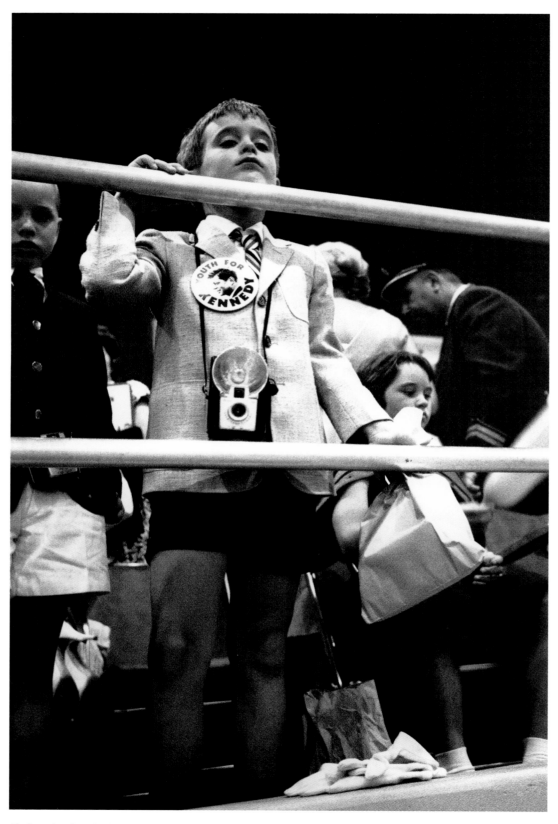

Christopher Lawford, son of Peter and Patricia Lawford, flanked by Robert and Ethel Kennedy's children, July 14, 1960

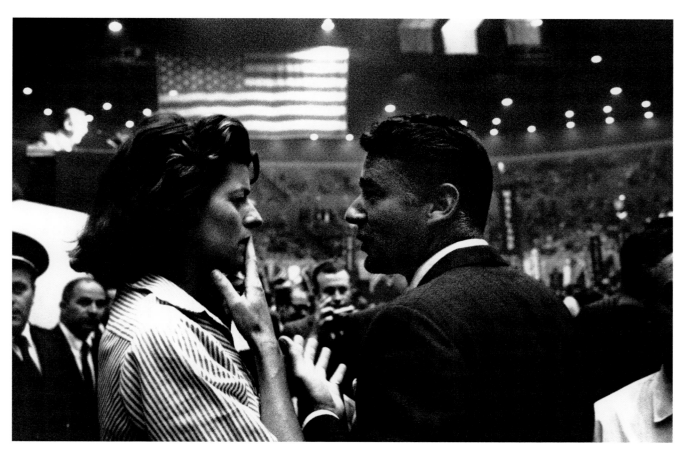

Patricia Lawford, one of Kennedy's sisters and a member of the California delegation, with her husband, actor Peter Lawford, July 13, 1960

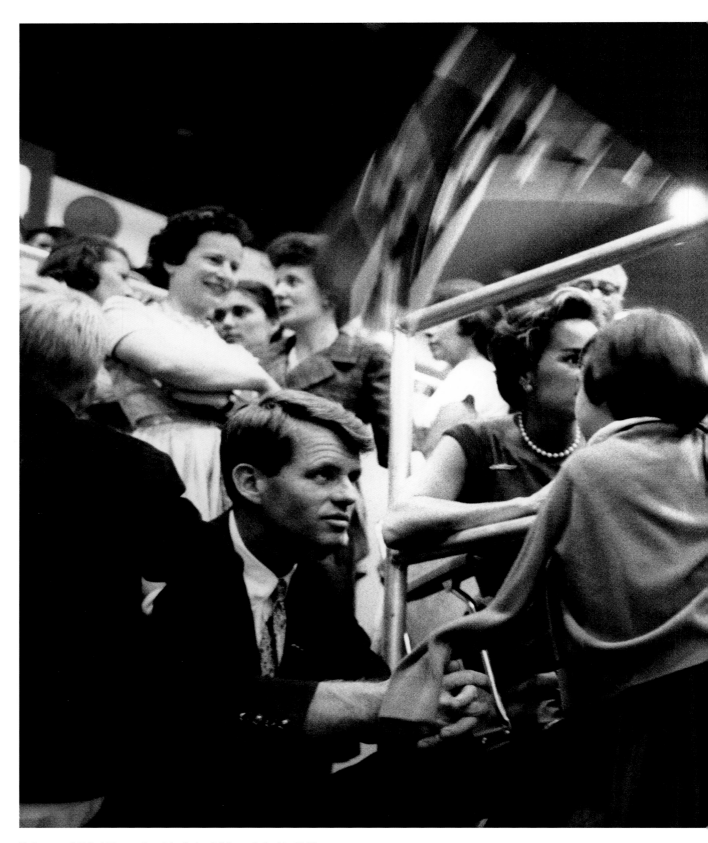

Robert and Ethel Kennedy with their children, July 14, 1960

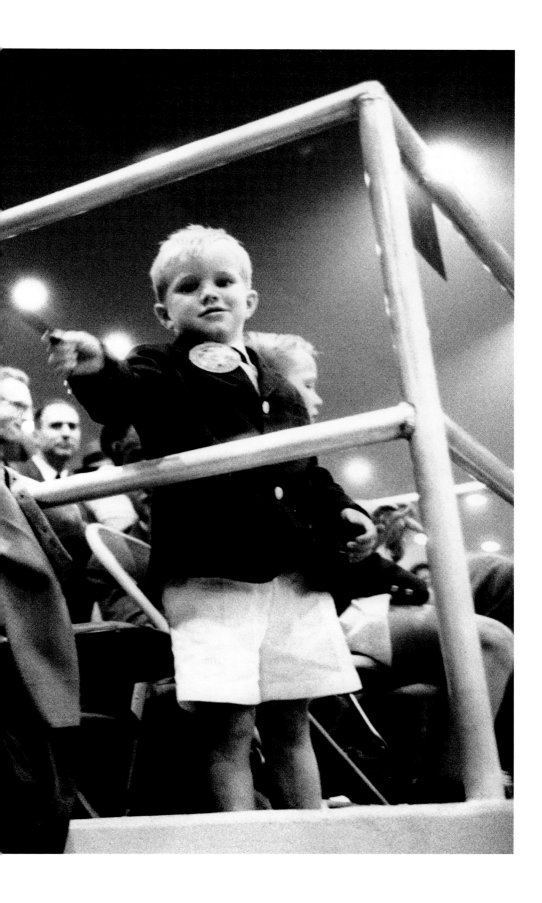

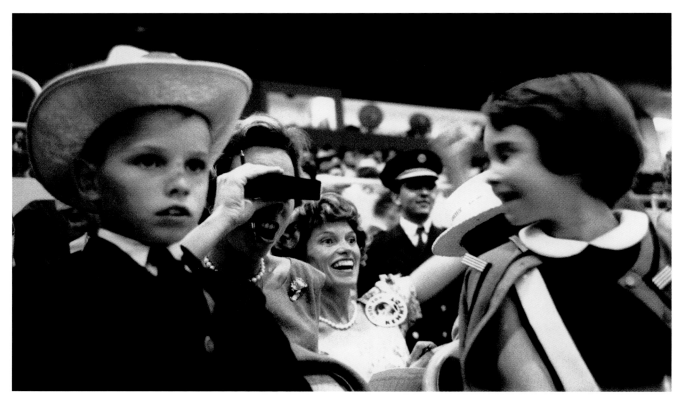

Published in a July 25 *Life* spread on the convention, this photograph was captioned: "As Joe Kennedy, 7, Bob's son, takes victory with male calm, his sister Kathleen, mother Ethel (with glasses) and aunt Eunice Shriver shout with joy." July 14, 1960

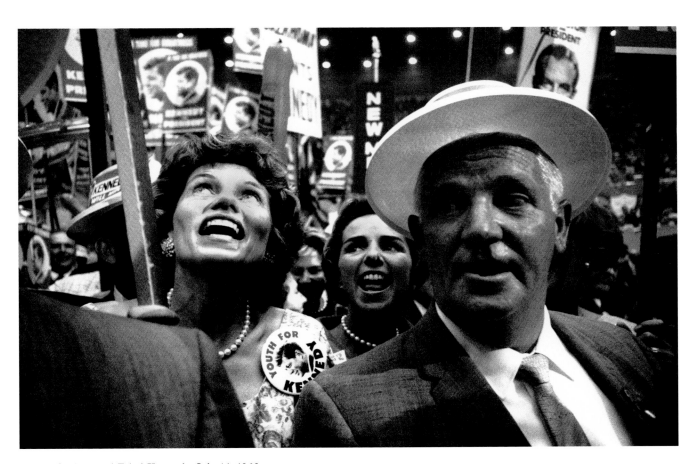

Eunice Shriver and Ethel Kennedy, July 14, 1960

Rose Kennedy, July 14, 1960

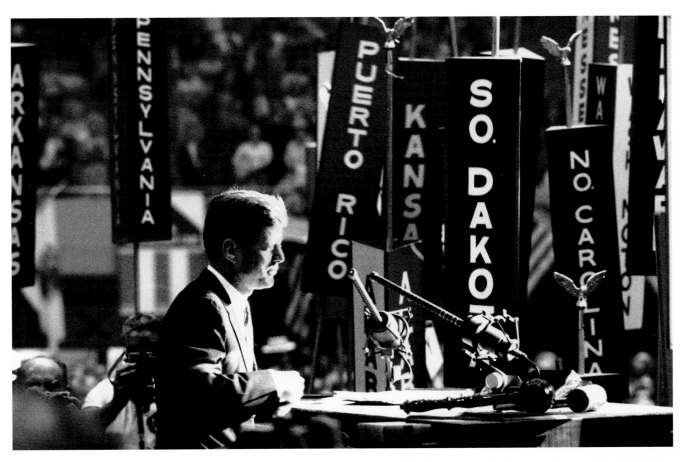

Kennedy making a brief acknowledgment immediately after the vote that gave him the Democratic Party nomination, July 14, 1960
His formal acceptance speech would be given the following day.

The Campaign Begins

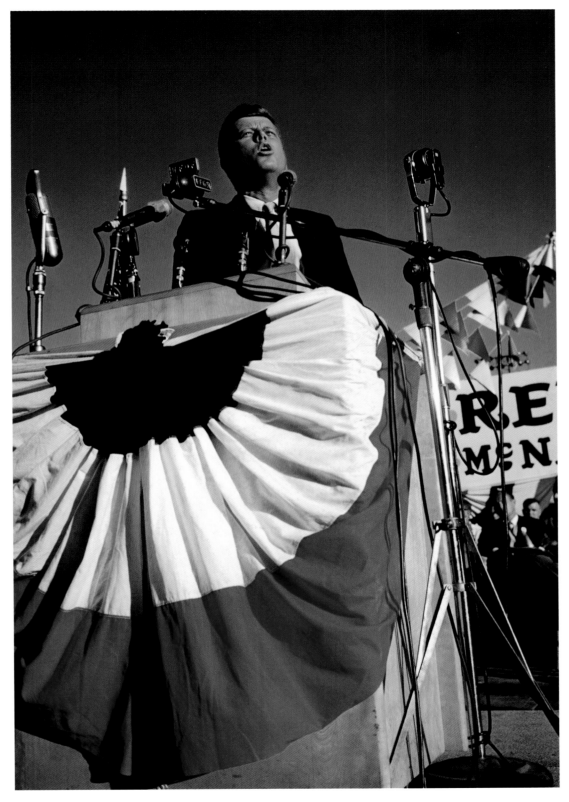

Michigan, September 5, 1960
Both parties' presidential campaigns were officially launched on Labor Day, September 5.

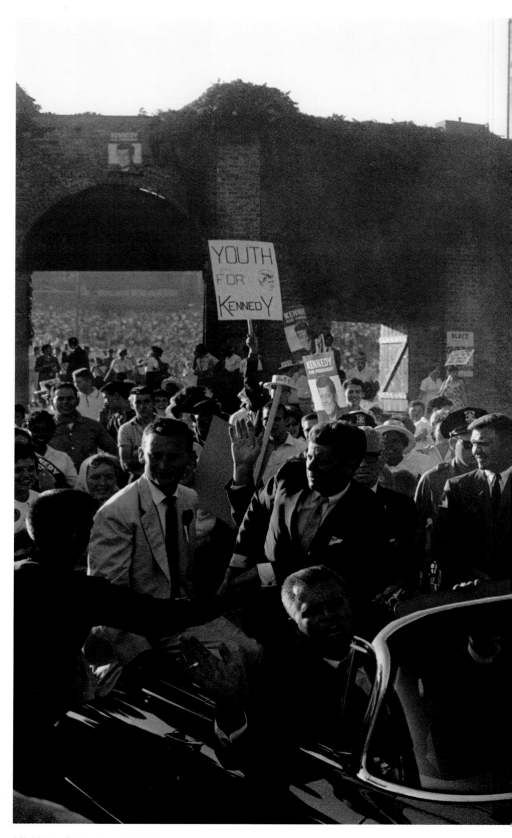

Michigan, September 5, 1960

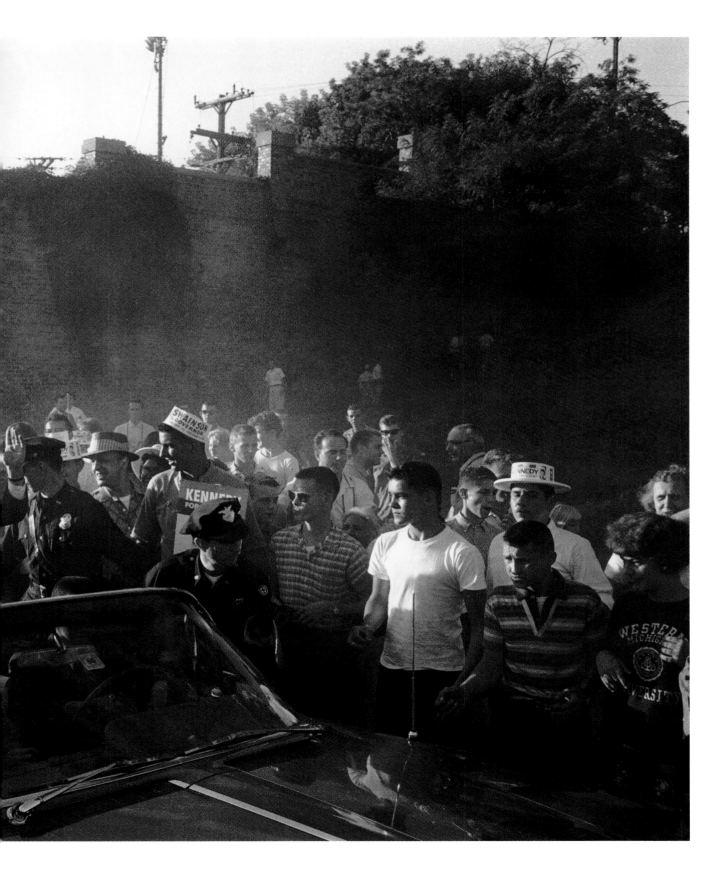

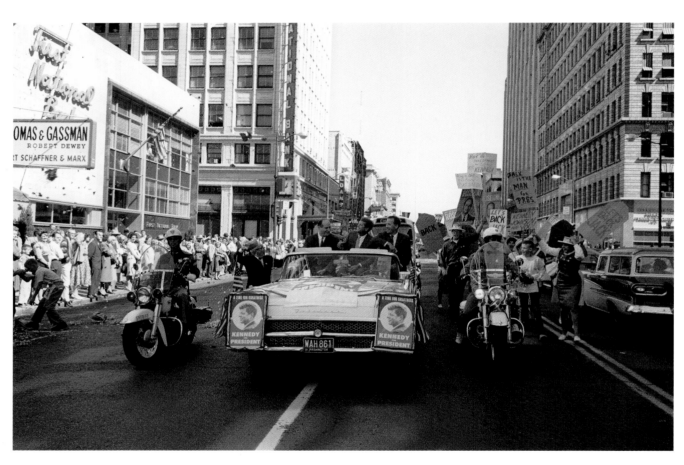

Spokane, Washington, September 6, 1960

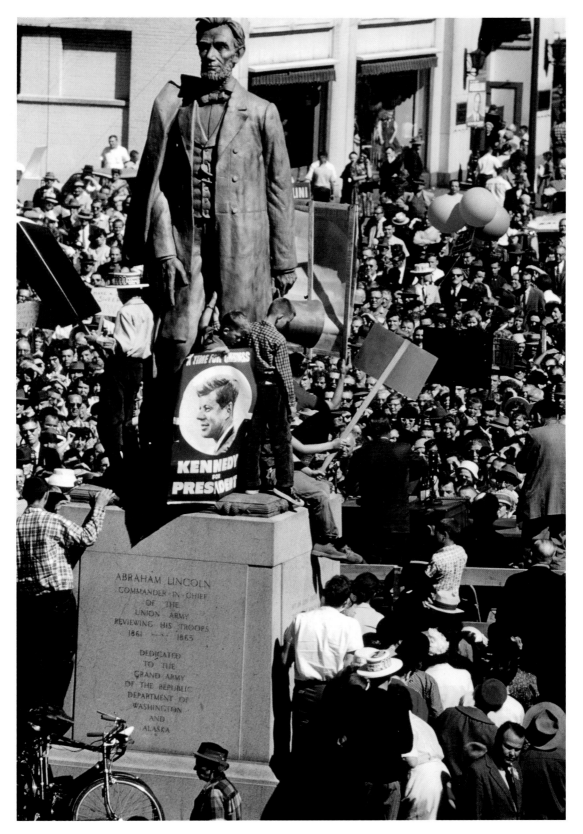

Spokane, Washington, September 6, 1960

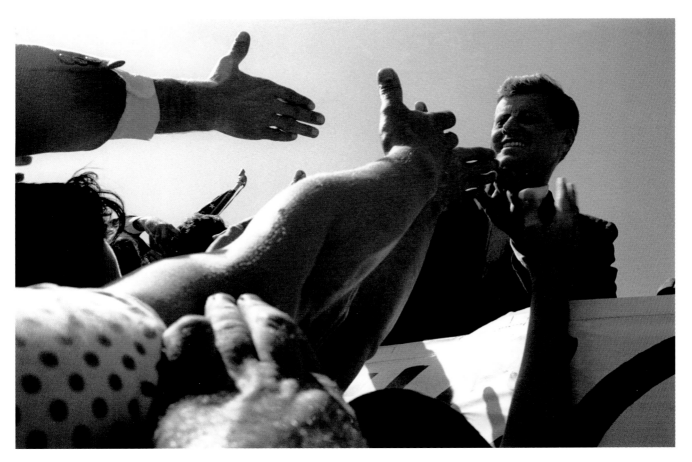

Michigan, September 5, 1960

The Whistle-Stop Tour

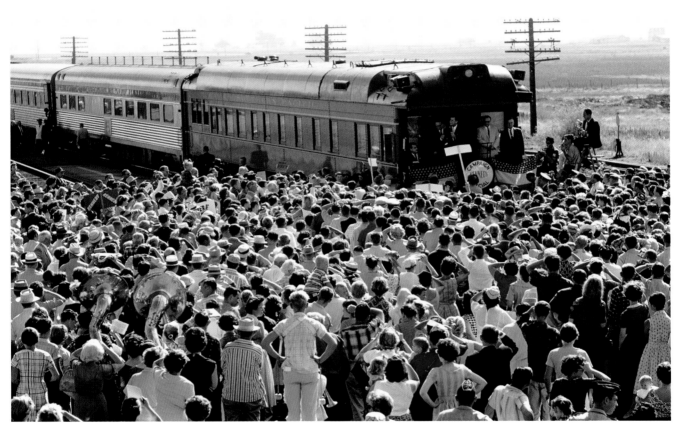

Kennedy speaking to voters from the back of his campaign train, September 8–9, 1960

Reviving what was already by 1960 a venerable but fading American political tradition, the "Kennedy Campaign Special" spent two days traveling south through central California. The candidate stopped in fifteen towns to give short speeches off the back of the train.

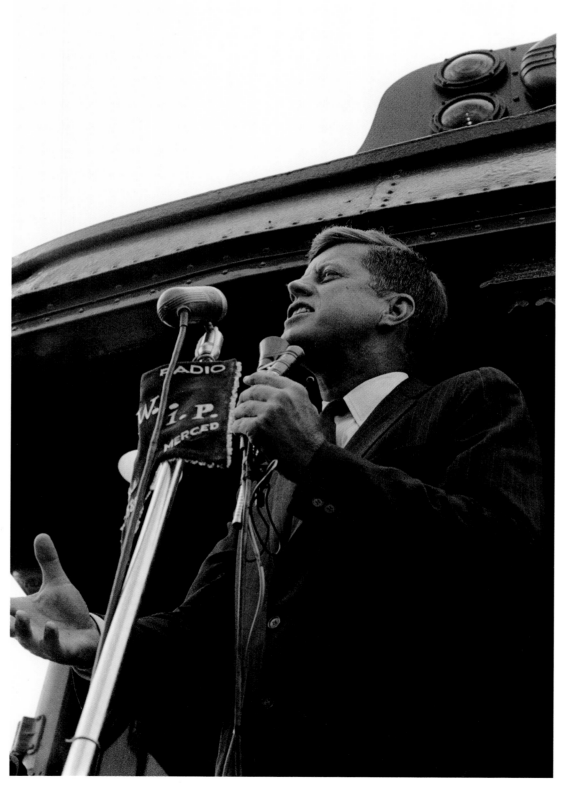

Merced, California, September 9, 1960

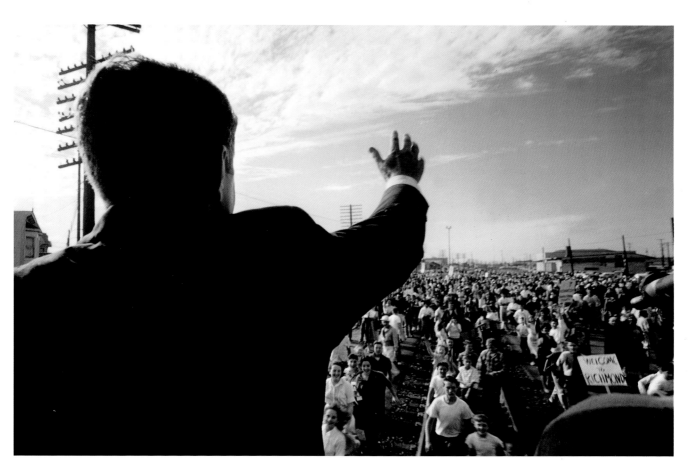

Richmond, California, September 8, 1960

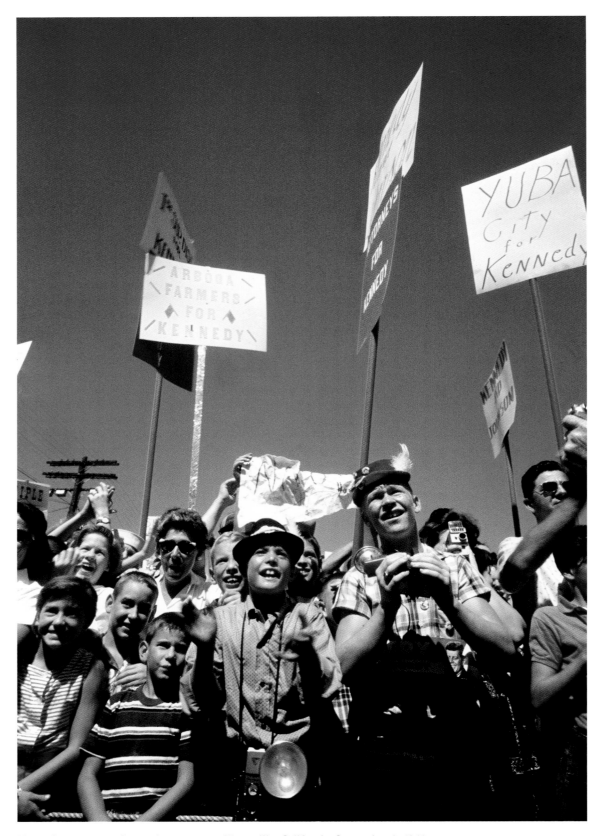

Kennedy supporters line train route near Marysville, California, September 8, 1960

Supporters cheering Kennedy's campaign train, California, September 8–9, 1960

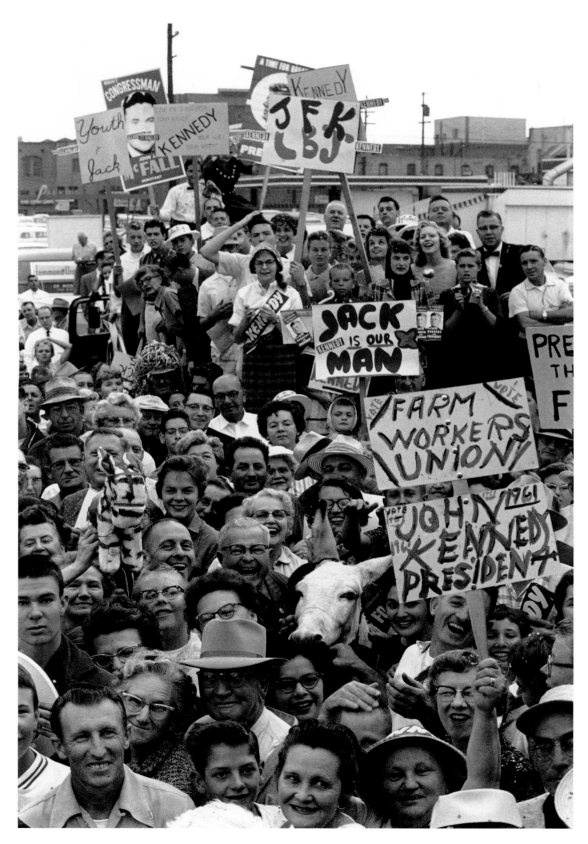

Near Merced, California, September 9, 1960

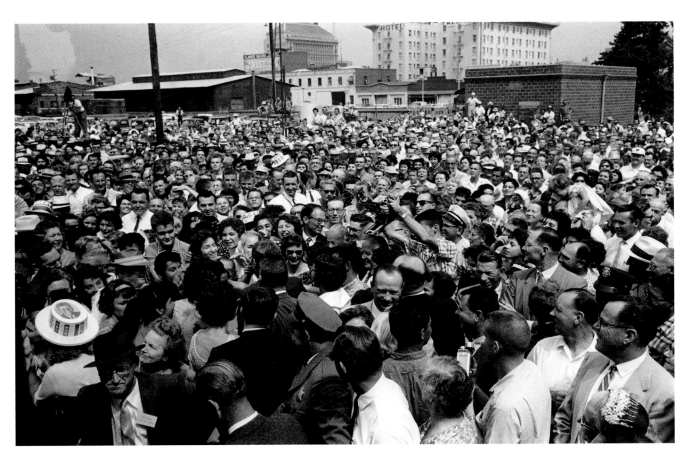

Near Fresno, California, September 9, 1960

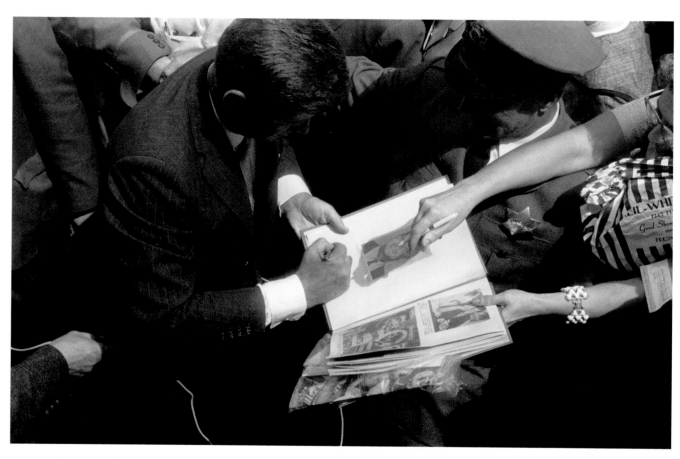

Autographing a scrapbook near Fresno, California, September 9, 1960

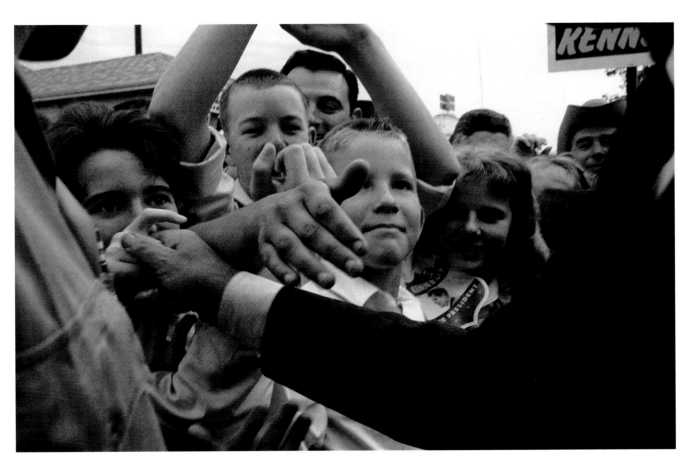

Near Merced, California, September 9, 1960

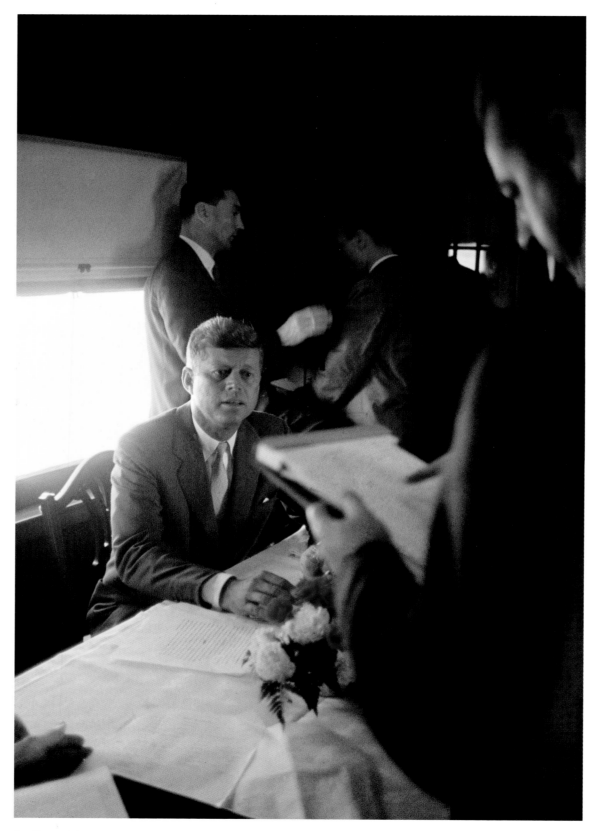

On Kennedy's campaign train, California, September 8–9, 1960

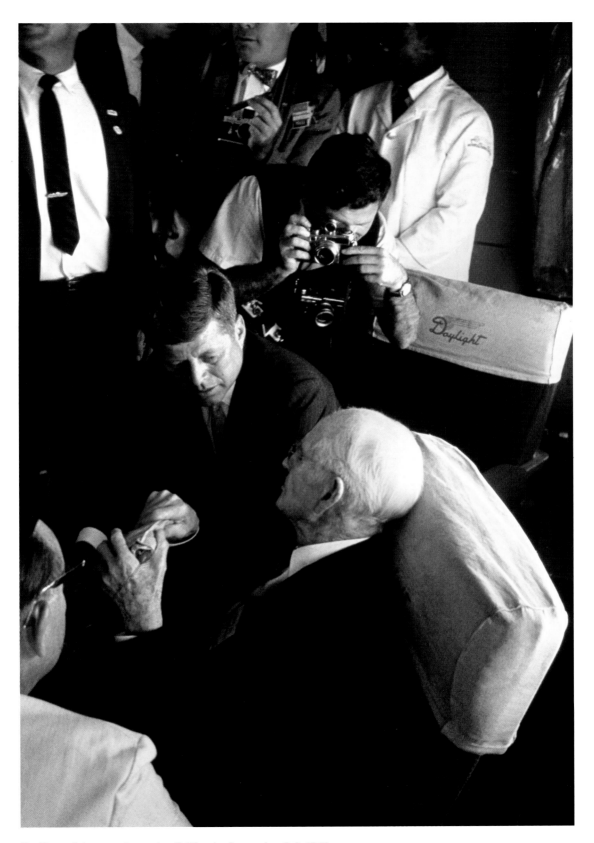

On Kennedy's campaign train, California, September 8-9, 1960

The Kennedy Campaign Special, September 8, 1960

On the Campaign Trail

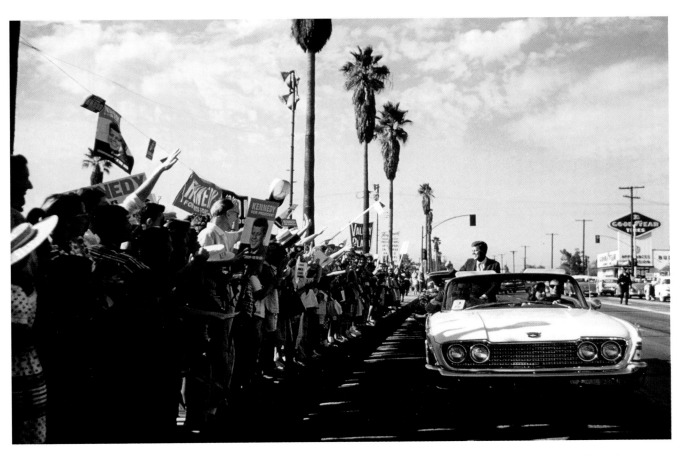

Kennedy riding in a convertible on Laurel Canyon Boulevard in North Hollywood, after his whistle-stop train tour through California, September 9, 1960
Kennedy is accompanied by his sister, Patricia Lawford. Jacqueline Kennedy was pregnant during the 1960 campaign season, and did not accompany her husband on many of his appearances.

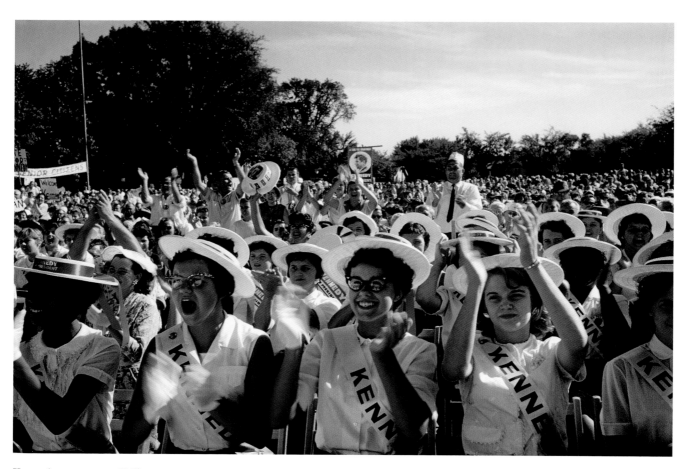

Kennedy supporters, 1960

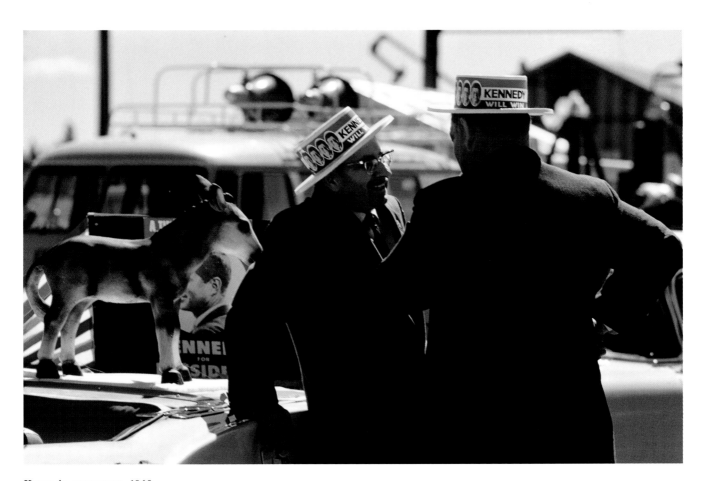

Kennedy supporters, 1960

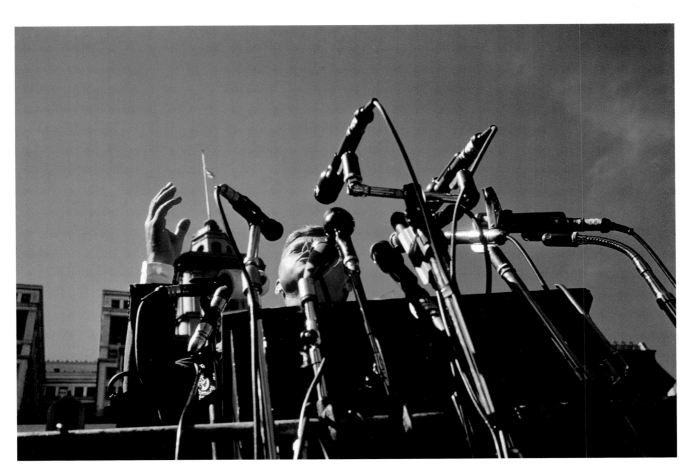

Campaign speech, 1960

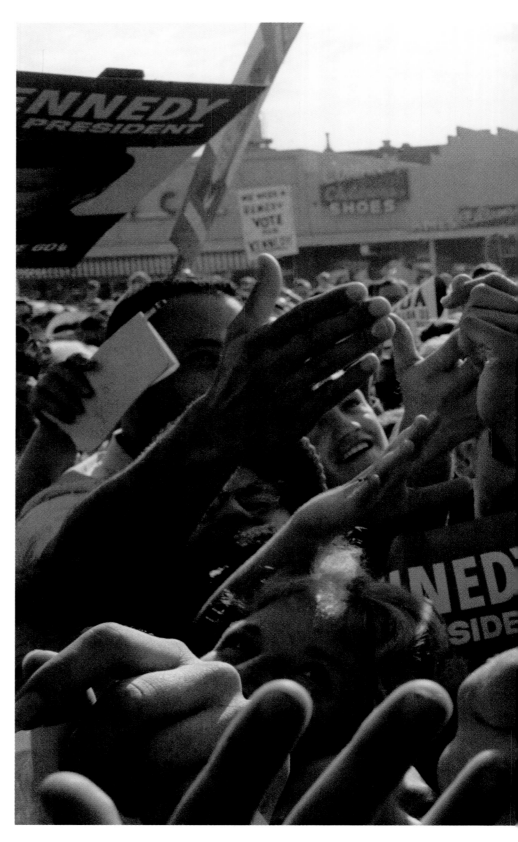

North Hollywood, California, September 9, 1960

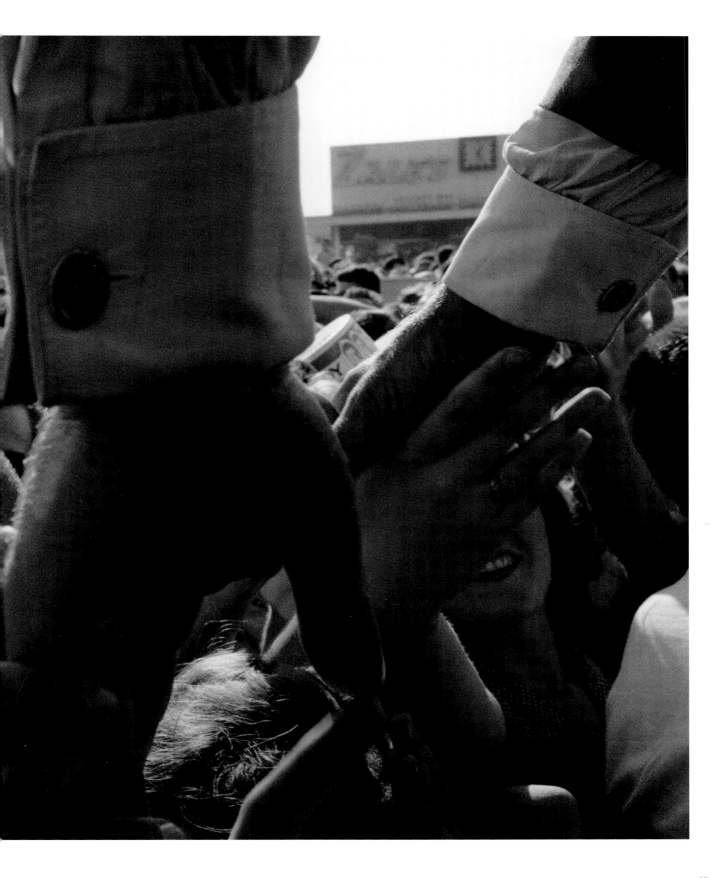

New York City

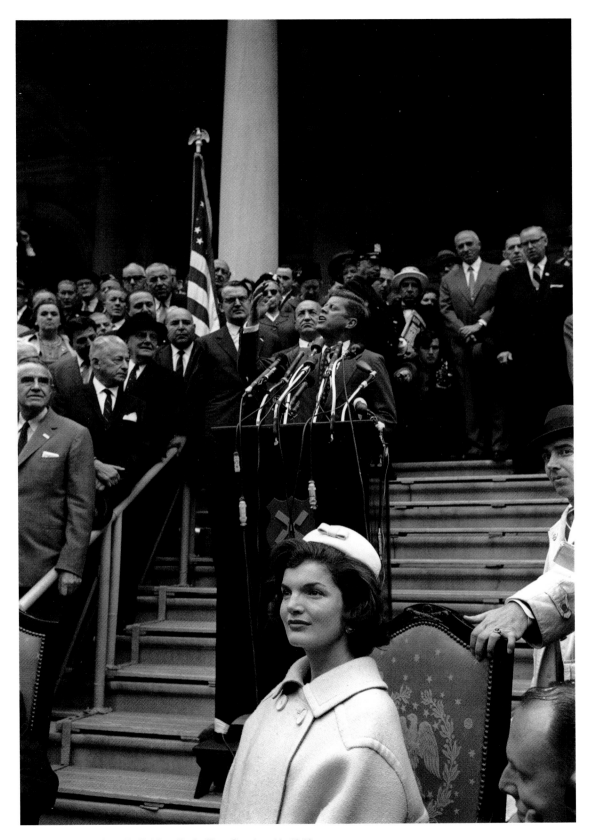

On the steps of City Hall, New York City, October 19, 1960

New York City, October 19, 1960

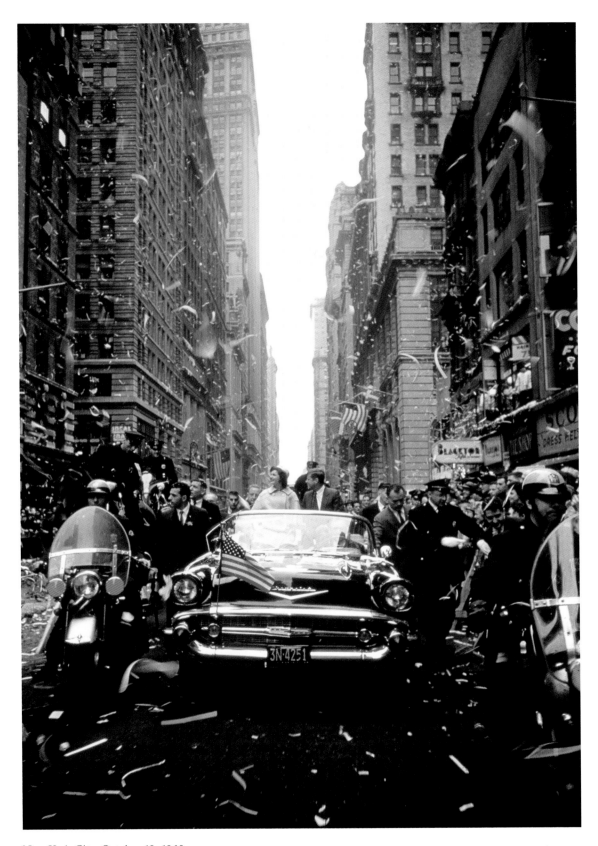

New York City, October 19, 1960

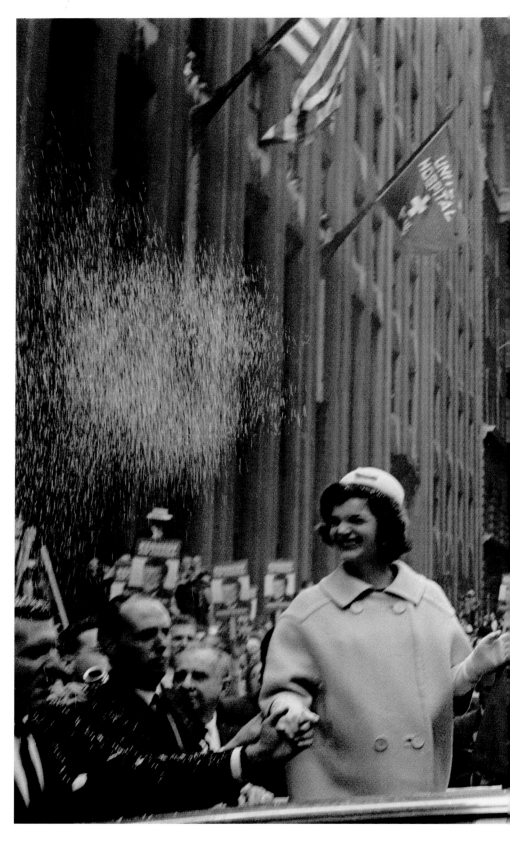

New York City, October 19, 1960

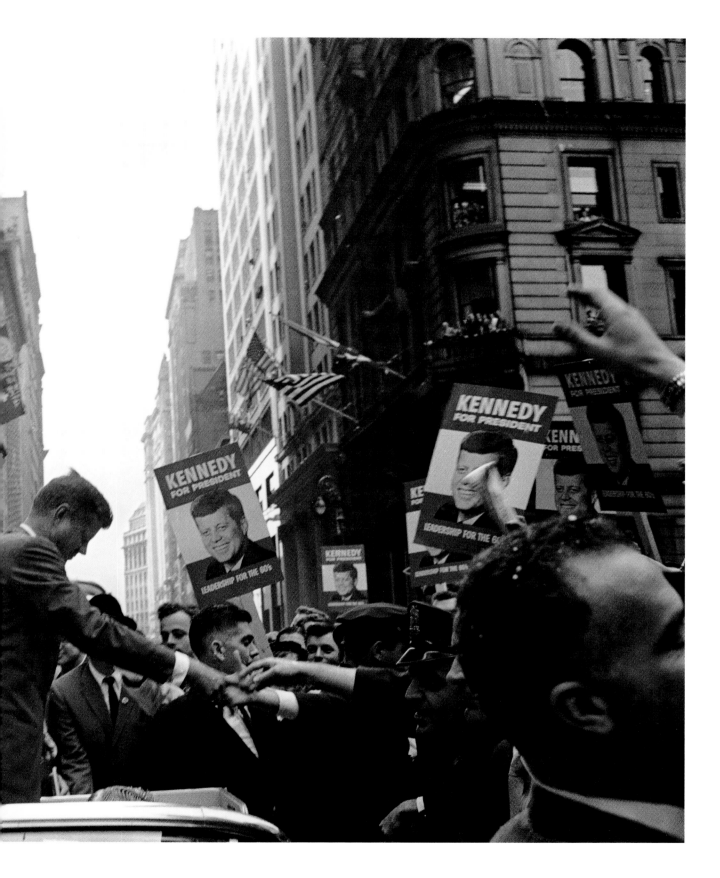

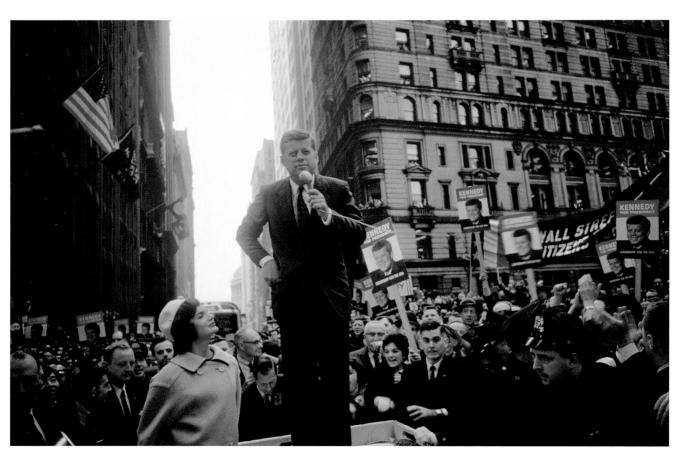

New York City, October 19, 1960

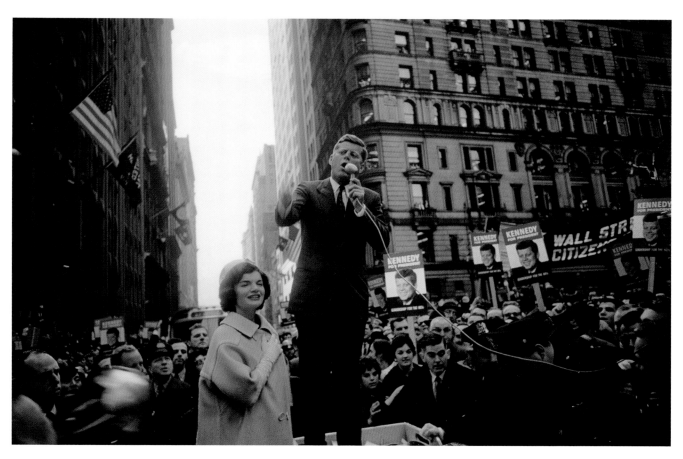

New York City, October 19, 1960

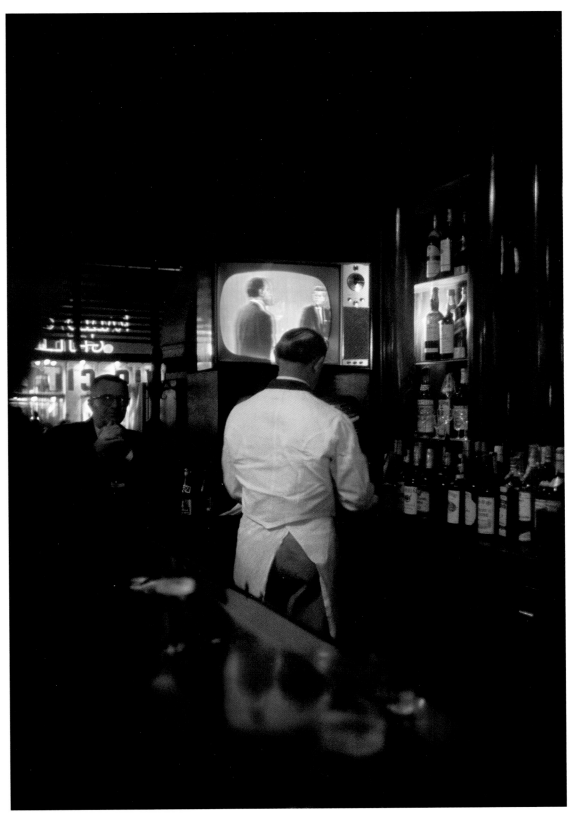

The fourth and last of the Kennedy-Nixon debates (held in New York City) as seen on the television
of a New York bar, October 21, 1960

Election Night

Democratic Party election-night headquarters, Biltmore Hotel, New York, November 8, 1960

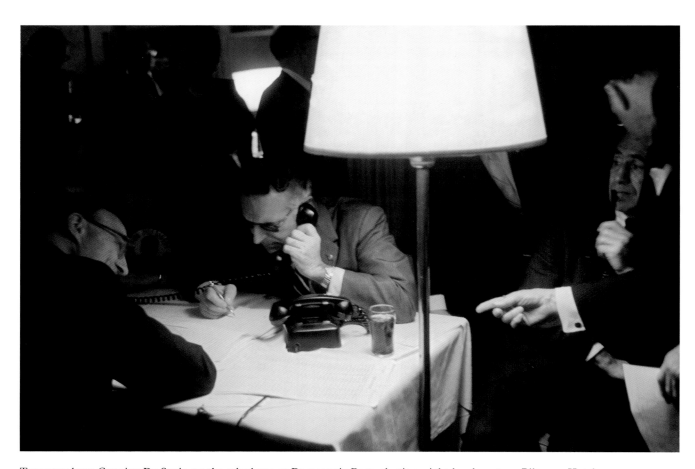

Tammany boss Carmine De Sapio on the telephone at Democratic Party election-night headquarters, Biltmore Hotel,
New York, November 8, 1960

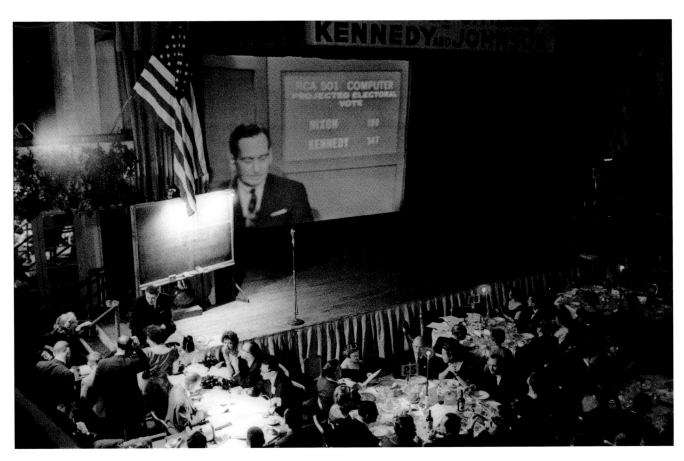

Benefit dinner held on election night by Democratic Party reform group New York Citizens for Kennedy and Johnson, Astor Hotel, New York, November 8, 1960

Inauguration

Washington, D.C., Inauguration Day, January 20, 1961

Washington, D.C., Inauguration Day, January 20, 1961

Washington, D.C., Inauguration Day, January 20, 1961

Let Us Begin:

The First 100 Days of the Kennedy Administration

Kennedy and William Walton, artist and family friend, the White House, early 1961
Inspired by Kennedy's inaugural address, Capa spent the early part of 1961 in the White House, photographing behind-the-scenes views of the president and his advisors for a book chronicling the administration's first 100 days.

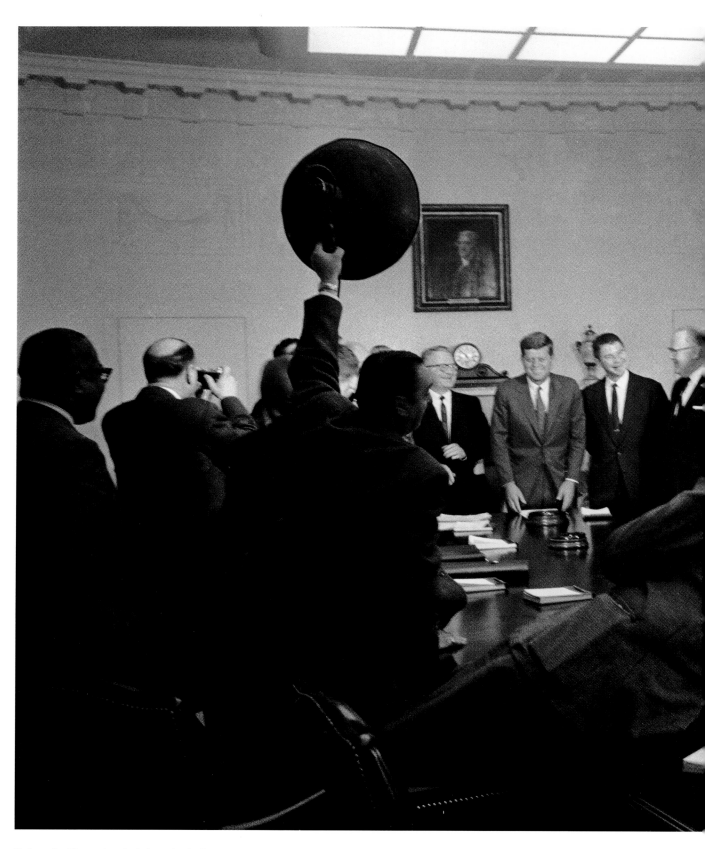

Before the Kennedy administration's first cabinet meeting, January 26, 1961

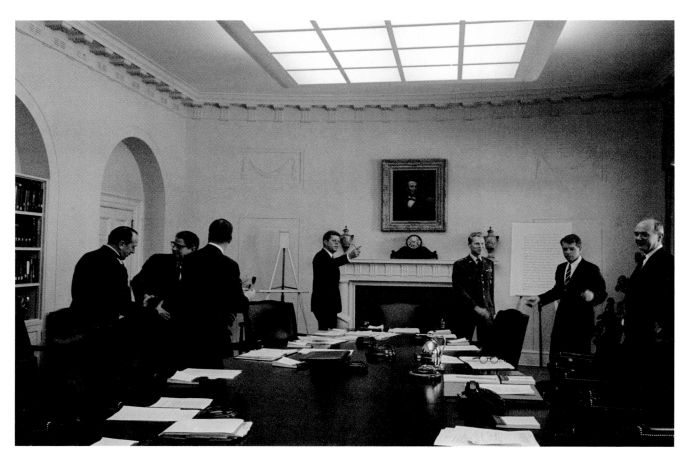

A cabinet meeting March 2, 1961
On Kennedy's right is NATO Supreme Allied Commander Europe Gen. Lauris Norstad, Attorney General Robert Kennedy, and Secretary of State Dean Rusk. Secretary of Agriculture Orville Freeman is second from left.

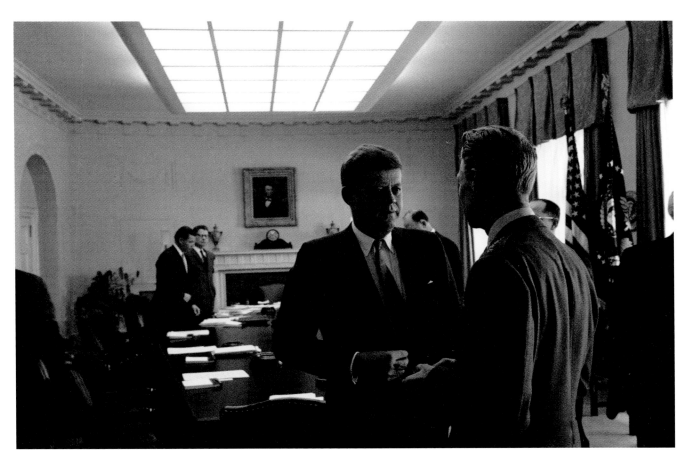

President Kennedy speaking with General Norstad at a cabinet meeting, March 2, 1961

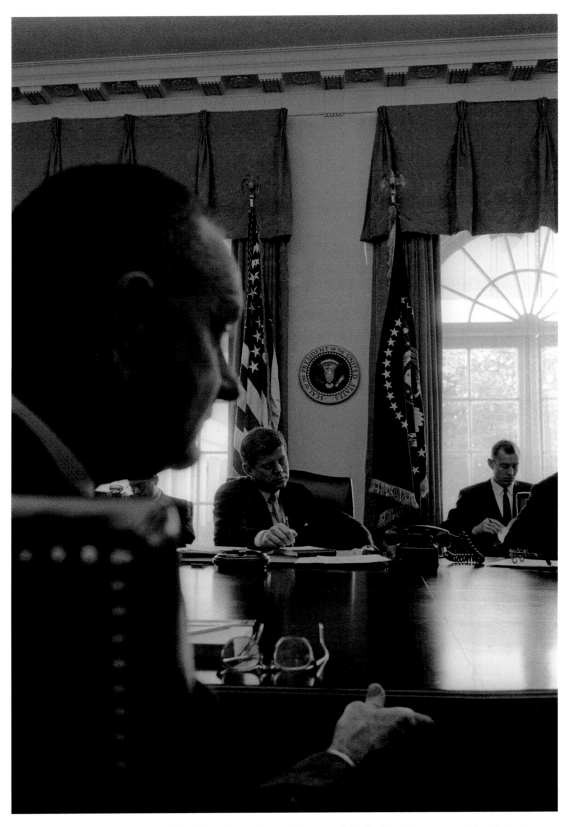

Vice President Lyndon Johnson, President Kennedy, and Bureau of the Budget Director David Bell during a cabinet meeting, March 2, 1961

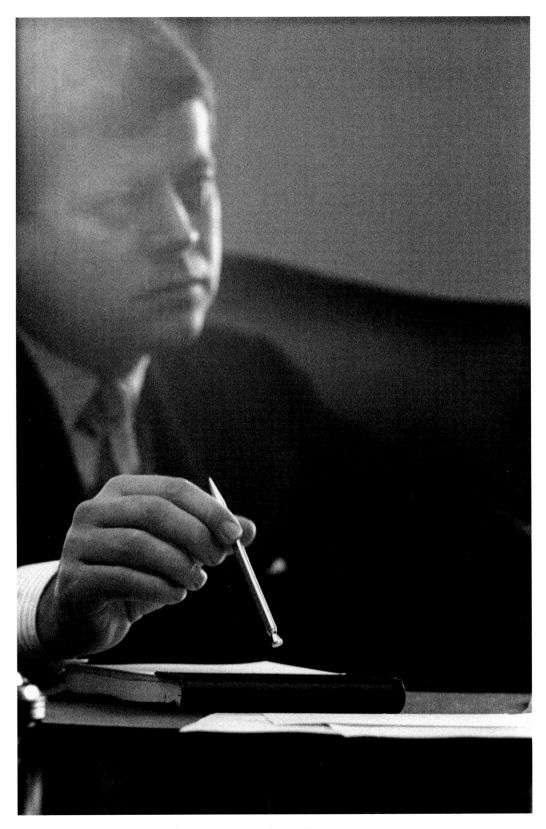

President Kennedy during a cabinet meeting, March 2, 1961

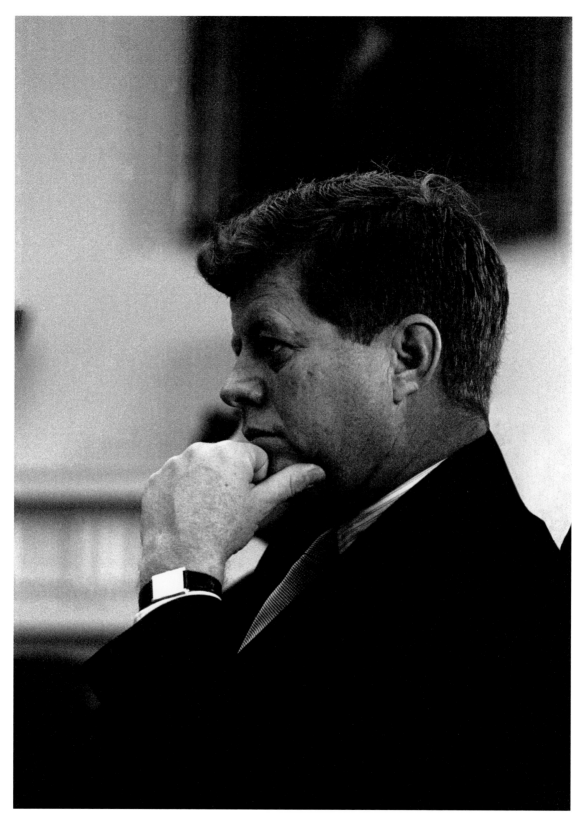

President Kennedy during a cabinet meeting, March 2, 1961

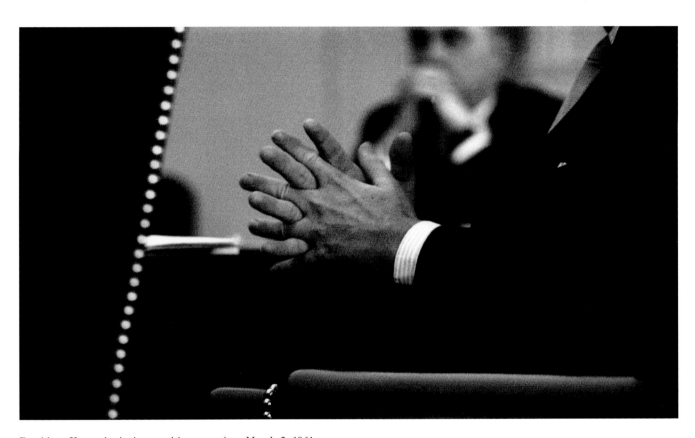

President Kennedy during a cabinet meeting, March 2, 1961

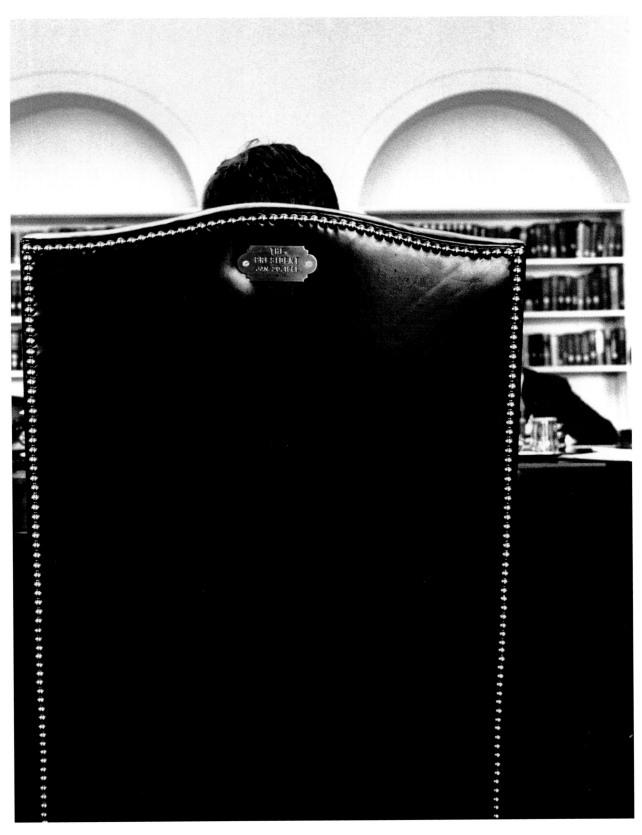

A cabinet meeting, March 2, 1961

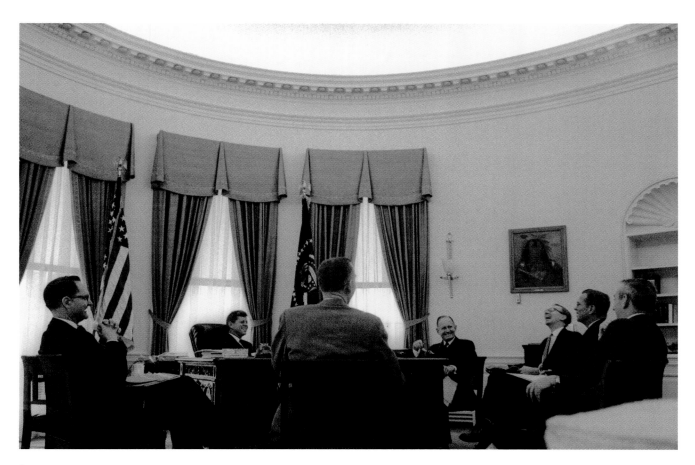

Secretary of the Treasury Douglas Dillon and other advisors briefing the president prior to a meeting with West German Foreign Minister Heinrich von Brentano, 1960
From left, Undersecretary of the Treasury Robert Roosa, Kennedy, Director of the Bureau of the Budget David Bell (back to camera), Secretary of the Treasury Douglas Dillon, economic advisor Walter Heller, and others.

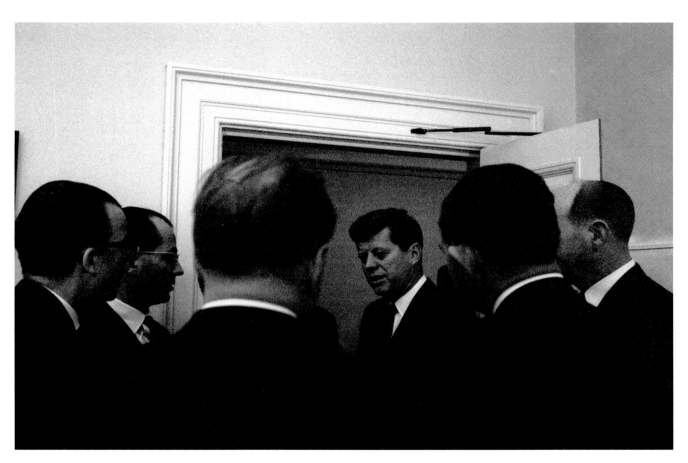

President Kennedy and Secretary of State Rusk with visiting German officials, 1961

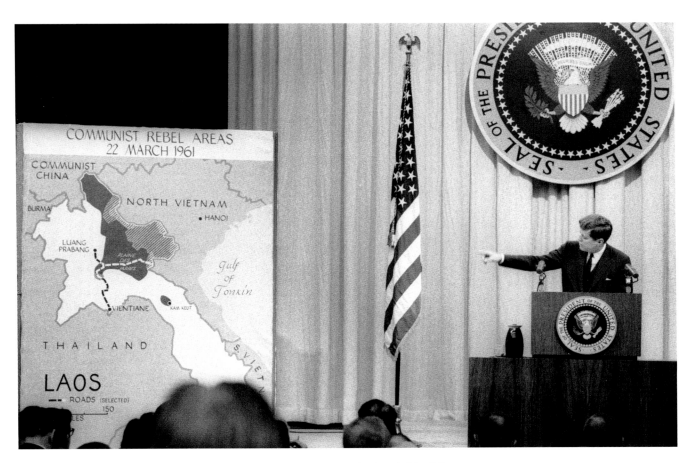

Televised press conference on the situation in Laos, Washington, D.C., March 23, 1961

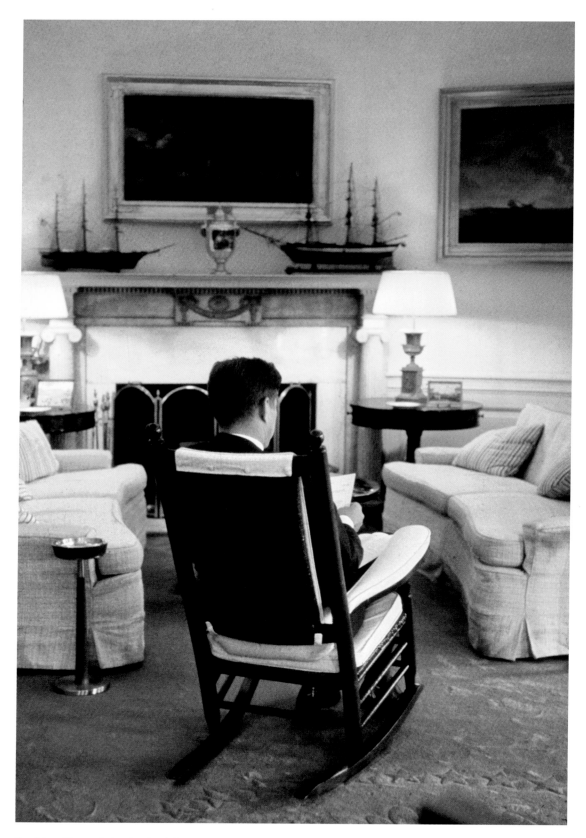

President Kennedy in the Oval Office, 1961

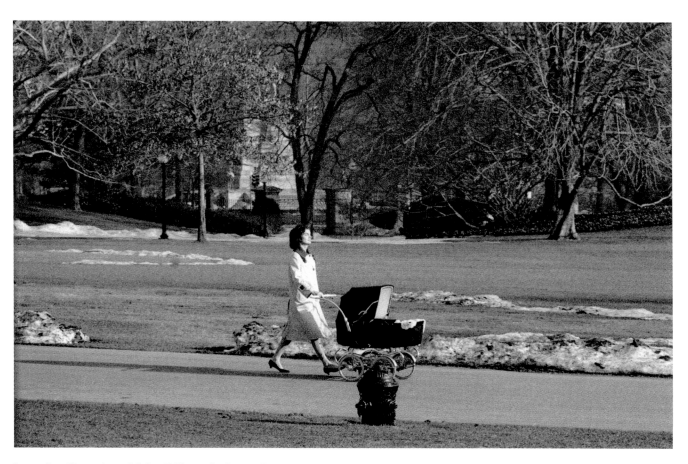

Jacqueline Kennedy and John F. Kennedy, Jr., on the grounds of the White House, March 1961

Europe, June 1961

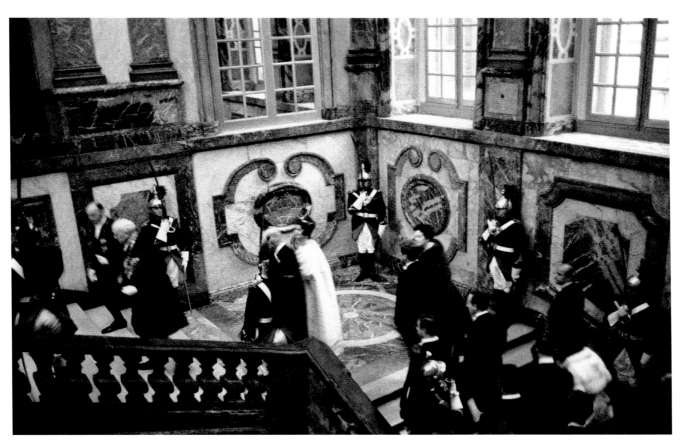

Jacqueline Kennedy and French President Charles de Gaulle, Versailles, June 1, 1961

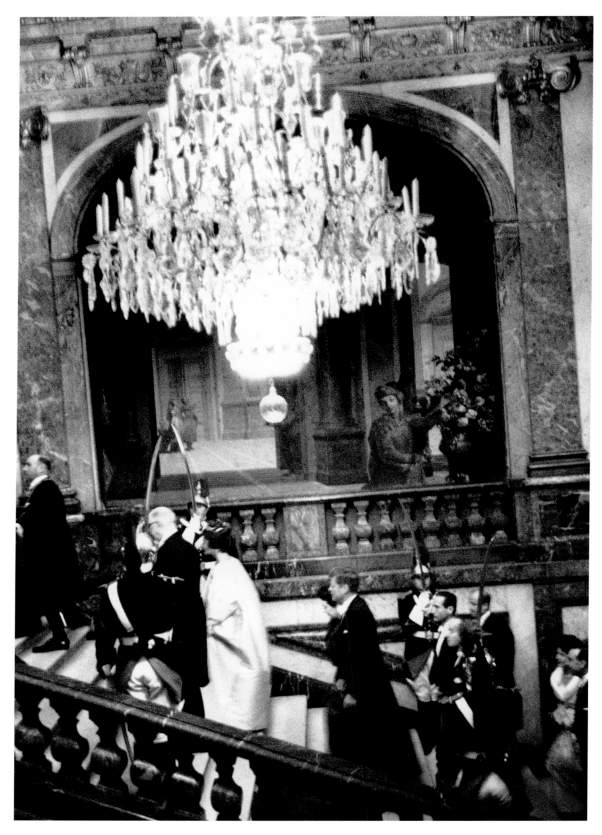

Versailles, June 1, 1961

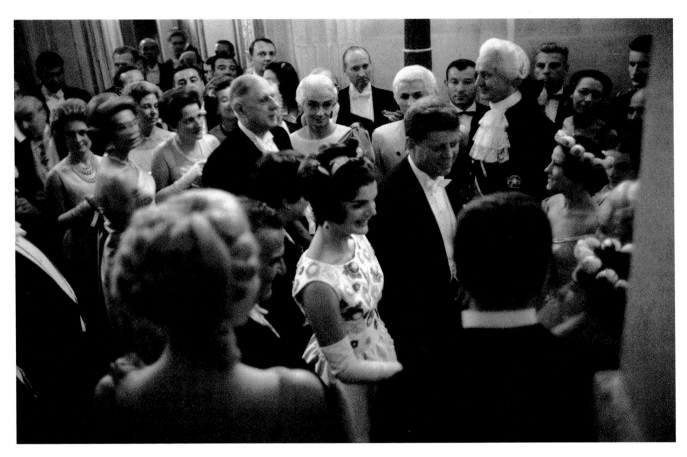

Versailles, June 1, 1961

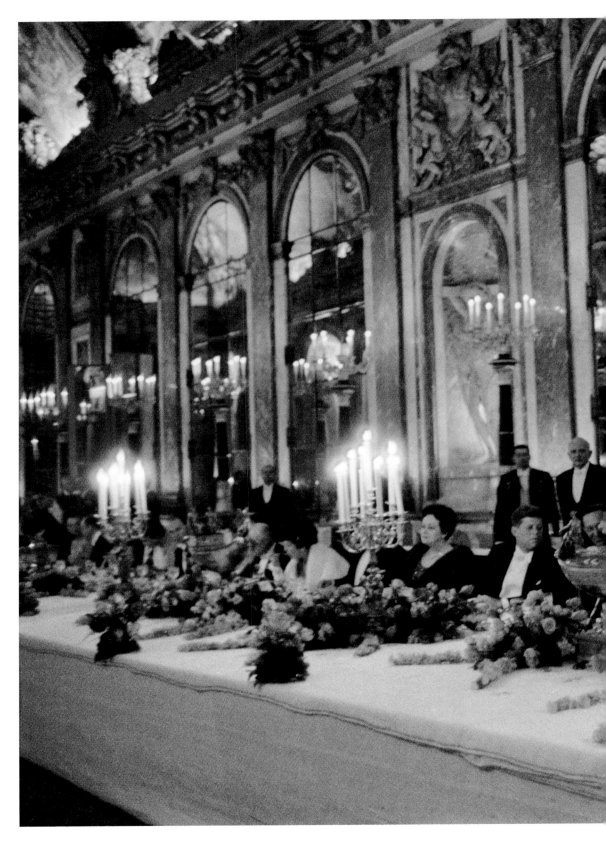

Banquet in the Hall of Mirrors, Versailles, June 1, 1961

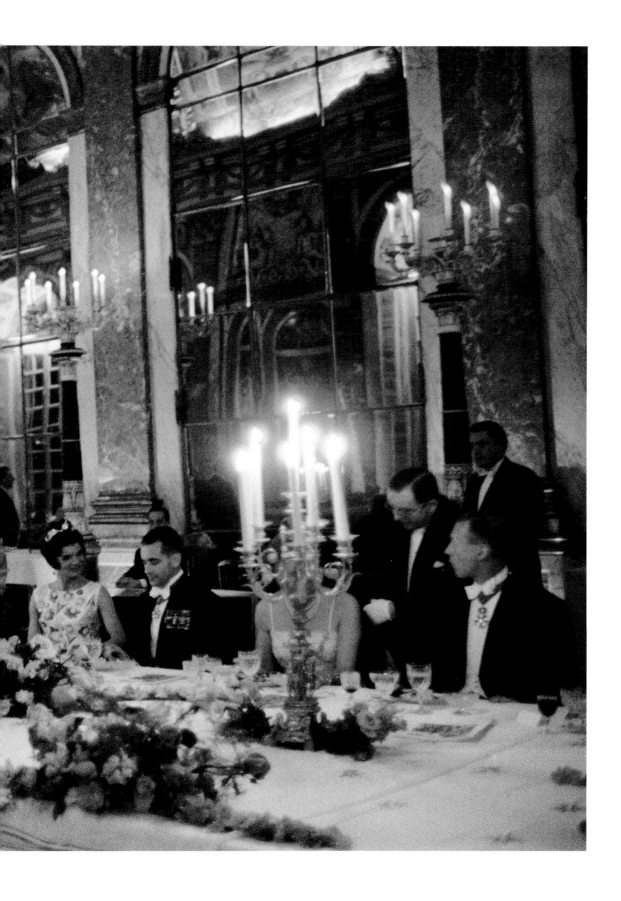

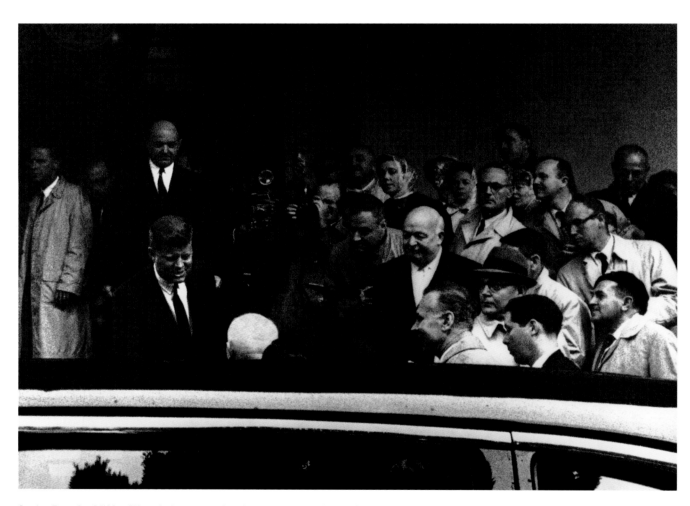

Soviet Premier Nikita Khrushchev emerging from a car outside the American Embassy, Vienna, June 3, 1961

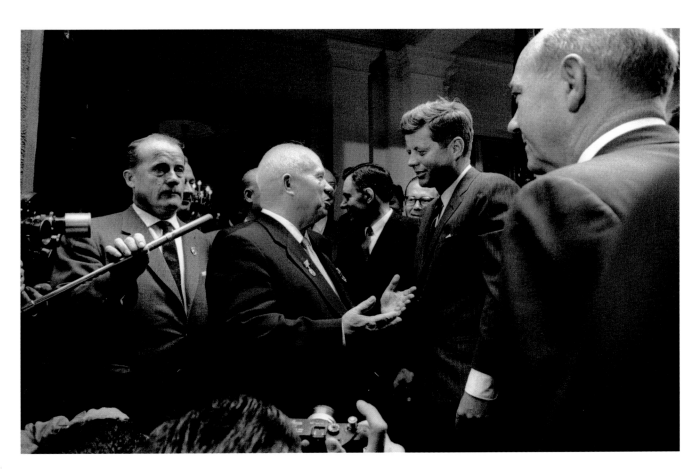

Outside the Soviet Embassy, Vienna, June 4, 1961

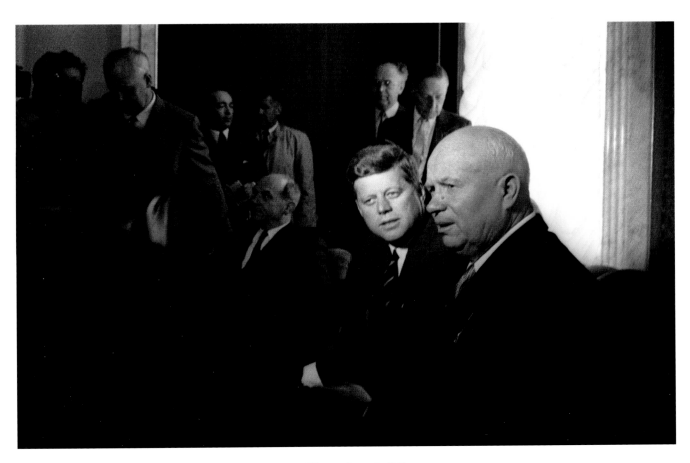

Kennedy and Khrushchev meeting at the Soviet Embassy, Vienna, June 4, 1961

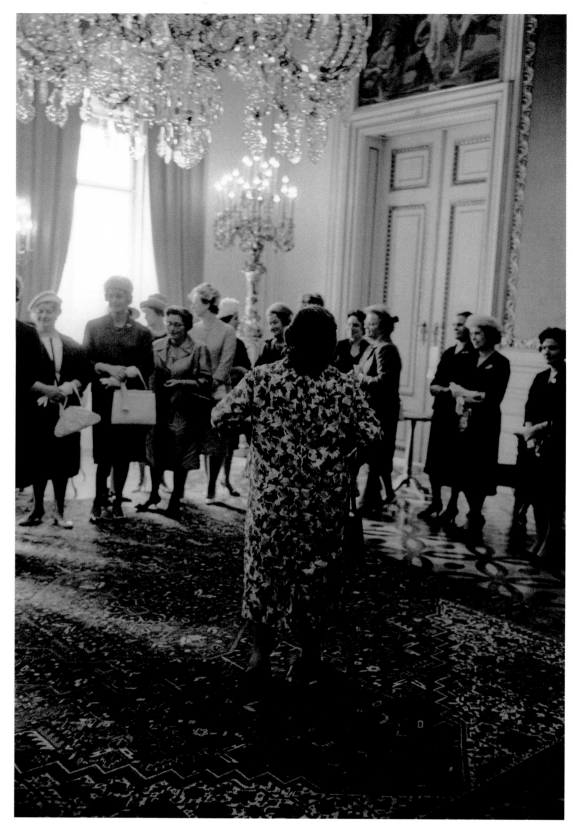

Nina Khrushchev, wife of the Soviet Premier, in the Pallavicini Palace, Vienna, Austria, June 4, 1961

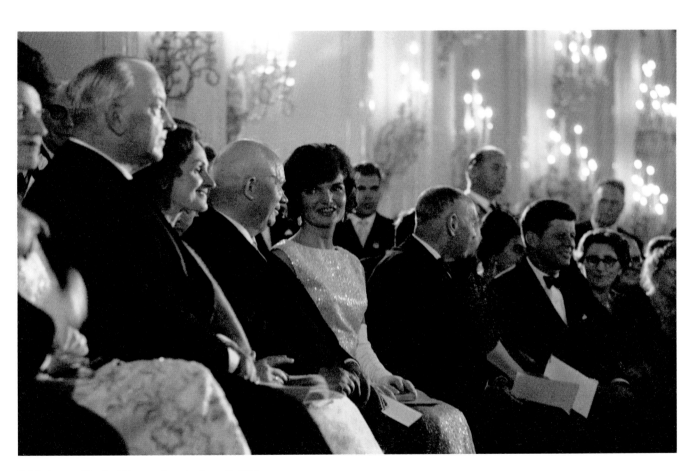

Schönbrunn Castle, Vienna, Austria, June 3, 1961

NEW GENERATION
from *Let Us Begin: The First 100 Days of the Kennedy Administration*

Eric F. Goldman

After the Inaugural Address, Dwight Eisenhower got rid of his tall silk topper, changed to his favorite homburg, drifted off with some friends to a luncheon at the 1925 F Street Club. How did it feel to be an ex-President? people kept asking him. "Great, fine," Eisenhower would reply, but beyond that he had little to say. It was not his day. It was not, emphatically, to be his kind of Administration.

The outgoing President believed that the Chief Executive should not attempt to run things too much and especially should not try to whiplash Congress and the nation into line. John Kennedy took office with whip brandished high. His models were the rambunctious Republican Theodore Roosevelt and the herd-riding Democrats Woodrow Wilson and Franklin Roosevelt. Shortly before Inauguration Day, he was reading with enthusiasm the book of a Columbia professor, Richard E. Neustadt, entitled *Presidential Power*, the theme of which was bluntly announced as "personal power and its politics: what it is, how to get it, how to keep it, how to use it." For a President to rule, action was necessary, and a swirl of action came from Kennedy's first hours in the White House. He hurried out into the January chill, hatless and coatless, to greet his first caller, Harry Truman, witnessed the collective swearing in of the Cabinet, fired off more nominations to the Senate, made his presence felt at a Democratic National Committee meeting, issued Executive Order No. I ordering Secretary of Agriculture Orville Freeman to double the rations of surplus foods provided to some 4,000,000 needy Americans. Incessantly Kennedy phoned, took calls, popped in and out of his office. That night the lights burned late all across the Executive buildings of Washington. In the Kennedy Administration, said Secretary of Labor Arthur J. Goldberg, "the deadline for everything is day before yesterday."

Amid the whirligig, the President took specific institutional steps to see to it that he ruled. Promptly he abolished the office that Sherman Adams had held; nobody was going to stand between him and his aides and the public. Almost as quickly he abolished the top-level Operations Coordinating Board set up by Eisenhower to bring together activities dealing with foreign policy. The President, said the Executive Order, intended to maintain "direct communications with the responsible agency so that everyone will know what I have decided." He further ordered the discontinuance of seventeen interdepartmental agencies, sixteen of them set up under Eisenhower. The directive saved more than $300,000 a year, but, as Presidential Press Secretary Pierre Salinger pointed out, economy was not the primary motive. The agencies were eliminated to "clarify and pinpoint executive responsibility."

Before long it was clear that Kennedy was using Cabinet meetings primarily as a symbolic institution. The Cabinet was meeting far less than under Eisenhower and making fewer collective decisions. The decisions were being made by John Kennedy alone, after consultation with individual departmental heads and other aides and after a relentless gathering of facts. Each Department was instructed to send detailed reports to the White House twice a week. In addition, a liaison man was established in every Department, and, depending on what kind of issue was urgent, one of these men might be contacted by the White House two or three times a day. "I never heard of a President who wanted to know so much," the State Department adviser Charles Bohlen remarked, and the whole capital soon agreed. At an early press conference, Kennedy answered in a detailed way a question that involved a proposed shipment to the United States of $12,000,000 worth of Cuban molasses. The reporters gasped. The information had appeared four days ear-

lier, down near the bottom of one of the Departmental reports.

Kennedy was so determined to keep control of things that more than one observer guessed he was resorting to the practice President Franklin Roosevelt had perfected—setting up conflicting and competing centers of power within his Administration to keep everybody on his toes and to see to it that no one became too entrenched. The most suggestive situation was in the most critical area—foreign policy. Across town from the White House, in an awesome office in the new State Department building, Secretary of State Dean Rusk was duly installed, but just a tunnel's walk from the White House, in the old State Department building, was the brilliant McGeorge Bundy with the highly flexible instruction to concern himself with "national security matters" and the decided practice of popping in and out of the President's office. Some commentators wondered whether Dean Rusk was not in danger of becoming the Cordell Hull of the Kennedy Administration, and McGeorge Bundy was not in a position where he could be the Harry Hopkins.

A good deal of the activity of the Kennedy Administration was politics—plain old-fashioned politics. Early in Eisenhower's first term a questioner had asked him how he liked politics and the President frowned. "Being President," he said, "is a very fascinating experience, but the word 'politics'—I have no great liking for that." Asked to comment on this quote, Kennedy snapped, "I do have a great liking for the word 'politics.' It's the way a President gets things done." The new President himself was endlessly receiving politicians. He or his aides were endlessly telephoning politicians, and the calls were not offhand. In the second-floor White House office of Lawrence F. O'Brien, special assistant to the President for "personnel and Congressional liaison," was a card file containing the background of every Senator and Representative. Among the details were the Congressman's close friends, his college fraternity, his wife's maiden name, his economic and educational milieu—information that has its uses. A tough, candid operator, O'Brien made it a point to talk over the President's program in detail with Congressional delegations, adding that the White House would call Congressmen with good news for constituents and the offices of Cabinet members would report unpleasant news. Congressmen quickly learned that when a man voted against the President, more and more of the news came from the Cabinet.

Amid all the glittering appointments Kennedy was making, there were also the careful political payoffs—most blatantly, the handout to Governor John M. Patterson of Alabama, who had declared for Kennedy when the South was still showing a notable resistance to his nomination. Patterson wanted a high-ranking job for his close political associate, Charles M. Meriwether, and the President named Meriwether a director of the Export-Import Bank. Republicans and some newspapers cried shame. The Export-Import Bank is an important agency that often deals with Asiatic and African nations. Meriwether was an acknowledged segregationist and one-time campaign manager for John Crommelin in a campaign marked by racist and anti-Semitic doctrines. Kennedy stuck by the appointment and the heavy Democratic majority in the Senate dutifully confirmed it.

At a press conference, a reporter brought up the Meriwether case.

He was confident, the President said, that Meriwether would do a "good job." And with that politico Kennedy pointed to the next questioner.

In the political maneuverings, in the policy making, in many of the day-by-day workings of the Administration, always and everywhere there was John Kennedy. "Under our system of government," he had once remarked, "the President is everything or he is nothing." This President, quite clearly, did not intend to be nothing. To increase the impact of his press conferences, he permitted live telecasts—the first in American history—and let it be known that he also intended to go on TV on a number of other occasions as soon as he had worked out the most effective format. In his first sixty days in office, Kennedy sent to Congress twenty-nine messages and more than a

score of draft bills; addressed twenty-eight communications to foreign leaders; made twelve public speeches; took a hand in answering an amazingly large number of the 30,000 letters that were flooding the White House every week. Now and again he even dropped in on Departmental meetings—sitting, chin in hand, listening closely and occasionally joining in the discussion.

Nothing was overlooked, including the attractiveness and bounce of the Kennedy family, to increase the President's hold on Washington and on general public opinion. Three-year-old Caroline Kennedy was beguiling as only a three-year-old can be, and newsmen were given full access to her activities. Everybody knew that when Truman came visiting the second time, Caroline stood grinning in her royal blue overalls and white sweater and her father had to nudge her. "What did I tell you to tell him?" "Oh, yes, you used to live in our house." And everybody knew how Caroline had gone wandering into the White House communications room one Sunday and, when a reporter asked, "What is your Daddy doing?" she said, "Oh, he's upstairs, with his shoes and socks off, doing nothing."

When the Caroline news ran thin, there were always the endless other Kennedys doing things. Soon the newspapers were carrying the story about Robert F. Kennedy, Jr., the seven-year-old son of the President's brother, the Attorney General. Bobby, it seems, had sent the President a note: "Dear Jack, I WOuld like To see YOU Soon by Jack." Bobby showed up at the White House every inch a news item, gray flannel suit neatly pressed, hair tousled, and carrying a seven-inch salamander, with black and yellow spots, in a glass vase.

"What is it?" asked the President as the flash bulbs went off.

"I don't know what it is. I caught it in the pool. They bite."

The President stirred the vase with a stick and the salamander turned over. "God, he's turned over," the President said. "What do you call him?"

"Shadrach," said Bobby, to the delight of millions of readers.

The trade papers of the fashion industry were featuring a different story. Women's shops across the country reported that customers were coming in by the thousands and asking for the "Kennedy suit," the "Kennedy coat," or especially the "Kennedy hat." But in areas like Fairfield County, Connecticut, specialty shops wanted no part of wholesalers who pushed "the Jackie Kennedy look." She wouldn't dare try to sell the clothes, one owner explained. "I'd lose the sale and probably the customer too."

The waspishness of the wives of the brokers and advertising men was only partly a result of partisan Republicanism. Jacqueline Bouvier Kennedy, she of the Dresden exquisiteness, so chic, so obviously the cosmopolitan socialite, was rapidly becoming a symbol, second in importance only to the President himself, not only of a way of dressing but also of a way of life.

Dwight Eisenhower's Washington had been the middle-class dream. The President headed a party which has spoken for decades with the accent of the business deal, the church supper, the golf course. Eisenhower liked the middle-class values, the middle-class manner, the middle-class joke. As he used to say, he enjoyed having those middle-class heroes, the successful businessmen, around him; their very success showed their high quality. They were around him in droves—as advisers and friends—and their attitudes seeped through the whole of Washington.

The opposition Democratic Party has been a peculiar institution in modern America. It has been, *par excellence*, the party of the poor or at least of the disadvantaged. But sometimes on the local level and much more on the national level, it has been led by people of the topmost social group. Eisenhower's first Secretary of the Treasury, George Humphrey, once remarked with almost as much accuracy as irritation, "The Democratic Party is led by men who inherited their money; the Republican Party, by men who made it themselves." Franklin Roosevelt, Adlai Stevenson, John Kennedy—all have been aristocrats (or, in the case of Kennedy, so close to it that the difference is unimportant) and all have had the patrician view of the world.

The American aristocracy is hardly easy to generalize about, but the members of the group who go into public life on the Democratic side do usually show certain characteristics. They have a certain patrician sniffishness toward mere successful businessmen (as the aristocrat Teddy Roosevelt said, such people need "education and sound chastisement"), a sense of *noblesse oblige* toward the less fortunate, a strong bent toward learning and the arts, and an enormous sense of personal security which makes them quite ready to be part of the informal, the new, the spectacular.

The Kennedys were soon giving Washington the authentic patrician air. Jackie Kennedy had under way a redecoration of the White House with the aid of Mrs. Henry Parrish, 2d, of New York, and what was happening looked like a redecoration by Mrs. Henry Parrish, 2d, of New York. Out from the White House, in French, went a phone call to Bui Van Han, the Vietnamese chef of the French Ambassador to England, who has the reputation of making the most delectable sauces in Western civilization. M. Van Han cabled, "Sorry cannot make the trip to become your chef," but it was clear that the White House was to be no steak-and-potatoes establishment.

The next week Mrs. Kennedy began making good her promise to turn the White House into "a showcase of American art and history," starting by throwing open to the public the beautiful Vermeil Collection of gold-finished chinaware. Gaily she talked of the parties she was going to have for artists and writers and of her plan to establish White House-sponsored prizes for literature and the arts. The President did not lag behind. His voracious reading was becoming a staple comment in magazine articles about him. He went on television to pay a tribute to his favorite poet, Robert Frost, and said: "There is a story that some years ago an interested mother wrote to a principal of a school, 'Don't teach my boy poetry, he's going to run for Congress.' I've never taken the view that the world of politics and the world of poetry are so far apart."

If the worlds of poetry and of politics remained a bit apart, the worlds of politics and of ideas did not.

The Harvard professors came flooding into Washington until everybody was repeating James Reston's crack that "Harvard will have nothing left but Radcliffe when Kennedy gets through raiding his alma mater." (Others savored the definition of a "failure" in the new Washington: "A Yale man driving an Edsel with a Nixon sticker on it.") But the members of the new Administration also came from throughout the American world of ideas—Walter W. Heller, from the University of Minnesota, to serve as Chairman of the Council of Economic Advisers; University of Virginia Law School Professor Mortimer M. Caplin, to be Commissioner of Internal Revenue; Edward R. Murrow, one of the country's most respected TV commentators, to direct the United States Information Agency; and George F. Kennan, leader in intellectual circles on both sides of the Atlantic, to represent the United States as Ambassador to pivotal Yugoslavia. As long as anyone could remember, the post of Postmaster General in the Cabinet had been the special preserve of the old-school politician, undefiled by books, ideas or anybody's new frontier. In the Kennedy era, few were surprised when the Postmaster General turned out to be J. Edward Day, University of Chicago Phi Bete, Harvard Law School honor graduate, author of two books—one of them a novel, *Barthalf Street*, which had Republicans sniffing whether it wasn't a bit raffish to be sent through the United States mails.

And through it all ran an informality such as Washington had never known. This was an Administration touched from top to bottom by the youthfulness, the self-confidence, the zest-in-everything of the patrician White House. For decades protocol had held that, as Herbert Hoover put it, "the President of the United States never calls on anyone." President and Mrs. John Kennedy went visiting friends like any other young couple—one of the first times, to the home of a newspaper reporter, Rowland Evans, Jr., of the New York *Herald Tribune*. At the President's gay, bantering luncheon for Congressional leaders, Republican Senate Leader Everett Dirksen was observed showing to Kennedy a twenty-five-cent key marked "The White House—Back

Door," which he had bought in a drugstore. He wouldn't have shown it to any other President, said Dirksen, but he had no hesitation in showing it to Kennedy. Reporters going to the White House to talk to an aide were likely to run into the President walking restlessly about the halls and, if the aide was busy, to be asked, "Why don't you come in the office for a while?"

One fine Saturday John Kennedy just upped and disappeared for three hours. Wouldn't Press Secretary Salinger try to find out where he was? the newsmen asked.

"I did make an attempt," said Salinger, "and nobody seems to know."

At the press conferences, in his talks with visitors, at dinner parties, the President was spraying everything with his quick, tart quips. Were all the newspapers talking about the rising influence of McGeorge Bundy? "I think I'll continue to have residual functions," said John Kennedy. He opened his first speech to a businessman's organization: "It would be premature to ask your support in the next election and it would be inaccurate to thank you for it in the past." After the appointment as Attorney General of his thirty-five-year-old brother, who had never tried a case in court, the President observed: "I can't see that it's wrong to give him a little legal experience before he goes out to practice law." As for the old pro politician Clark Clifford, a top Truman aide and the man who took charge of the transition from Eisenhower to Kennedy, the President told a dinner party: "Clark is a wonderful fellow. In a day when so many are seeking a reward for what they contributed to the return of the Democrats to the White House, you don't hear Clark clamoring. He was invaluable to us, and all he asked in return was that we advertise his law firm on the backs of the one-dollar bills."

Soon the informality of the whole top Administration had Washington old-timers rubbing their eyes. McGeorge Bundy, forty-one, went hustling through the tunnel connecting his office and the White House looking like a cocky young Ivy League instructor. Secretary of Labor Goldberg, the second oldest man in the Cabinet at fifty-two, whirled around

five states on an inspection of recession spots, startling unemployment offices by his sudden appearances and observing, "This is the way we'll be doing things." Ex-Governor of Michigan G. Mennen (Soapy) Williams, forty-nine, Assistant Secretary of State for African Affairs, took off for Africa, promptly had Western European chancelleries in an uproar by declaring that he believed in "Africa for the Africans." Unperturbed, his green polka-dot bow tie chipper as ever, Williams hurried on, joining with a group of Congolese schoolboys in rendering "Nobody Knows the Trouble I've Seen," dipping his finger into an African chicken dish with gooey sauce called "moambe," licking the finger, and pronouncing moambe "good stuff," stripping down and wading into the mud to help tribesmen build a dike.

Meanwhile visitors were noticing a football sitting on the fireplace mantle in the office of Attorney General Robert F. Kennedy. Their curiosity was promptly satisfied. Attorney General Kennedy, varsity end at Harvard, and Deputy Attorney General Byron R. White, Phi Bete, Rhodes Scholar, Yale Law honor graduate, and the "Whizzer" White who was everybody's All-American in 1937, liked to toss the football around while deliberating matters of jurisprudence.

Long before the Kennedy Administration was a reality, far back in the strange West Virginia primary campaign, a special note had been sounded. The miners and the hill folk would gather, heirs to generations of bitter anti-Catholic feeling, and they would look at the Catholic Kennedy and mutter, "I don't know about voting against that young man. He reminds me of F.D.R." The campaigning for Kennedy by Franklin Roosevelt, Jr., was a smash success. To many a West Virginian the two men seemed natural together, and both recalled the leader of the 1930s who, as a miner in Boone County put it, "really cared about us nobodies."

Throughout the 1960 campaign and the early period of the Kennedy Presidency there was plenty to keep fresh the comparison with the days of F.D.R. Kennedy's choice of Lyndon Johnson as his Vice

Presidential running mate was a repeat of the 1932 Roosevelt-Garner ticket—the more liberal, Northeastern No. 1 candidate and the more conservative, Southern No. 2 candidate. Midway in the campaign of 1960, in a speech to which the Democratic camp gave special emphasis, Kennedy heightened the comparison by pointing to the so-called "Hundred Days" which opened the New Deal. The way the Roosevelt Administration began, Kennedy declared, showed that "the first ninety days of the next President's Administration will be the crucial days," and that he, as President, proposed to act accordingly. Kennedy's victory pattern repeated the old F.D.R. coalition—the South plus the big cities of the North, with a special boost from the minorities of the big cities. And a thousand things, little and big, about the new Administration called up memories of the Roosevelt era—whether the general air of innovation or the President's zest in politicking, the onrush of intellectuals or the lights burning late all over Washington.

Yet 1961 was hardly 1933. John Kennedy had no landslide mandate from the American people. As a matter of fact, there were still plenty of Republicans growling that the handful of votes which separated Kennedy and Nixon had been stolen in the wards of Chicago. The United States, although worried by recession, was not in the fourth year of a depression which had put it in a mood where Will Rogers could say, "The whole country is with him [Roosevelt]. Even if what he does is wrong, they are with him. Just so he does something. If he burned down the Capitol, we would cheer and say, 'Well, we at least got a fire started anyhow.'" Instead the United States was, as Kennedy's intellectual friends had been emphasizing for a long time, in a mood of deep complacency. The Congress that came in with F.D.R. was so bewildered and frightened that Administration bills could be jammed down its throat with scarcely a whimper from them. (Not untypically, Roosevelt's banking legislation was debated by the House of Representatives for thirty-eight minutes and by the Senate for three hours.) The Congress that faced Kennedy was even more Republican than it had been under Eisenhower and just as influenced by a conservative Republican-

Southern Democrat alliance. If Kennedy burned down the Capitol there would be millions—led by their Congressmen—to shriek, "I told you so."

Apart from any differences in specific practicalities, the oncoming era bore its own special mark. A Washington veteran caught the heart of the matter when he remarked, "No one could possibly say that this Kennedy Administration has much resemblance to the Eisenhower days. But whenever I hear it compared to the Roosevelt period, I'm uncomfortable. It's not that it's different in particular important ways—that isn't the real point. There's a much deeper, more subtle difference, something you have to call style or tone, or, as the sociologists like to say, a difference in its image of itself."

The subtle difference had been a long time in the making. Somewhere at the beginning of the twentieth century a strangely assorted group of Americans began to influence the national destiny. They were shaggy agrarians storming against the plutocracy of the East, Eastern aristocrats irritated at what the parvenu industrialists were doing to the country, little old ladies skittish at the thought of men working seventy hours a week, socialists with angry Utopias in their pockets, Single Taxers, labor unionists, progressives, syndicalists, not to speak of the rampant Theodore Roosevelt. They really had little in common—little except one potent idea. America was a very special place, something unique in all the history of man's aspirations. The uniqueness was not that the United States was a political democracy, where men could duly vote and even hod carriers could become Senators. The uniqueness was that America was the land of economic and social opportunity. And, the reformers went on, an alliance between the new industrialism and corrupt politics was seriously, outrageously, cutting down this opportunity for the ordinary man.

The reformers of the early twentieth century talked little about the rest of the world. Like most of the population of the United States, they assumed that the business of America was America. It was to get on with this business without dependence on other nations and without interference from them. At

times, of course, there would be an interruption when some foreign nation, acting in a way that foreigners persist in acting, went berserk. Then the matter was to be settled by diplomacy or war but, whatever the technique, quickly and finally.

The reformers were the more inclined to believe in the quick, total solution of any world problem because they were so sure that the world was no great problem anyhow. They tended to assume a general international trend, a trend so certain that it took on the cast of a law of history. Human beings everywhere and at all times, the law ran, seek peace and democracy, want to get ahead to a farm of their own or a house on the right side of the tracks, prefer to do it gradually and with a decent regard for the amenities. The history of man is consequently a long, slow swing toward a world consisting entirely of middle-class democracies. Once in a while the trouble comes when some country falls under an evil leader who forces it along a road forbidden by the law of history. Then it is only necessary to remove the leader and let things flow back along their proper path. If such was the law of history itself, how could foreign policy be a problem requiring anything except the occasional surgical removal of an unnatural growth?

Behind all the attitudes of the reformers, in foreign or domestic affairs, was a faith, a credo so assumed that it rarely had to be spoken. Human beings are inherently good. Give the ordinary fellow a reasonable amount of opportunity, a sound house over his head, decent clothing, enough food so that tomorrow's dinner is not a constantly nagging problem, and he would emerge a balanced, kindly human being, quite interested in the general welfare.

Over the decades these American reformers continued to urge a vast variety of techniques to protect and broaden opportunity in the United States, but more and more they agreed on the use of governmental powers—particularly the powers of the Federal Government—as the most effective means. They continued to call themselves by a grab bag of names, but increasingly they were known as "liberals." The liberals scored continuing successes in the early twentieth century, were thrown back, broke into their heyday

under the redoubtable Franklin Roosevelt. By the mid-1930s they were as cocky as F.D.R.'s uptilted cigarette about themselves and their doctrine—and they seemed to have every reason to be. When World War II came, most liberals broke with their old homeward-lookingness and took up some degree of internationalism in their thinking. But for only a few did this mean any basic reassessment of their ideas or of their faith, about America or about the world.

Then, suddenly, it happened. Liberals had hardly brushed the V-J confetti out of their hair when they were jolted by a hard fact. Something was decidedly wrong with their law of history. Around the world millions of men and women, far from moving gradually toward middle-class democracy, were hurtling off in an entirely different direction. Worse still, they were hurtling off in a way that threatened to bring into action the shockingly new fact of life—annihilation bombs.

Meanwhile, more gradually, the consummation of liberal dreams was bringing liberal nightmares. In post-World War II America, the great waves of prosperity kept rolling across the nation. Opportunity was everywhere. Jackie Robinson, dazzling the stands in his Dodgers uniform, was a flashing symbol of an era when for all poor men and for all minority groups the economic and social walls were coming tumbling down. And there he was now, the liberal's dream, the ordinary American, well housed, well fed, well clothed, freer from discriminations than all his ancestors—there he was, the liberal's dream and the center of a mass culture which could appall and frighten. The years of savage McCarthyism especially troubled liberals. For the bellowing Senator, a menace to everything reformers stood for, roused his most fervid support precisely in the part of the population which the liberals had labored so hard and so hopefully to uplift—the new middle classes.

Other liberal successes created still more liberal worries. The liberal now had his big government, big beyond the fondest wishes of the early 1900s, and it could haunt him. Even the Federal administrative commissions, through which big government was to do so much of its good work, recalled the words of the

astute railroad attorney Richard Olney, commenting on the Interstate Commerce Commission when it was created far back in 1887. Olney told a railroad baron to cheer up, for the Commission "is, or can be made, of great use to the railroads.... [It can be employed as] a sort of barrier between the railroad corporations and the people and a sort of protection against hasty and crude legislation hostile to railroad interests.... The part of wisdom is not to destroy the Commission, but to utilize it."

Since the turn of the century, the liberals, in the name of the general welfare, had been especially favorable toward the oppressed farmers and the downtrodden workingmen. Now the biggest American labor union was led by none other than Jimmy Hoffa. The farmer, more than likely, was making $10,000 a year and was ready with a pitchfork for anybody who talked about cutting his Federal subsidies in the name of the general welfare. Above all, the liberal had staked his hopes on the democratic process—"The cure for any ill of democracy," as generations of reformers said, "is more democracy." But in an era of highly organized political parties using intricate organization, huge sums of money, and public-relations techniques little different from the ways of selling soap, the faith in the sheer democratic process had become quaint, to be remembered, as one remembered Teddy Roosevelt's teeth, only in a haze of mezzotint sentimentality.

All during the post-World War II period of liberal disillusionment and rethinking, a new group was beginning to filter into positions of leadership in politics, the universities, business and the world of letters. Chronologically, as President Kennedy said in his Inaugural Address, they were men born in the twentieth century. But in a more important sense they were the sons of the New Deal, men who were just coming to maturity as the domestic New Deal slid into history. Their first real experiences were fighting World War II and living and thinking during the development of the East-West clash, Korea, McCarthyism, and the emergence of an affluent, intensely group-centered, banal America.

Very few of these new leaders were conservatives.

Very few were liberals in any traditional sense of the word. (Most of them, if they did not blanch at being called liberals, also did not delight in the description.) The 1930s were the years of ebullient, confident, uncomplicated liberalism. Now a Post-Liberal Generation was coming into its own under Post-Liberal John Kennedy and giving to Washington a tone that was neither Dwight Eisenhower nor Franklin Roosevelt.

In part, the Post-Liberals are quite ready to follow the long-running liberal emphases. They seek to go on protecting and broadening opportunity in America and they depend heavily on government as their means. They keep a good deal of the ultimate liberal faith that human beings can be excellent, or at least better. In part—but beyond these fundamentals almost everything is different, especially in the nuances that mean so much.

In one important respect, the Post-Liberal Generation has stood traditional liberalism on its head. The center of concern is no longer America; the focus is on the world and America's relations to it. It is no accident that Roosevelt's first Inaugural was almost exclusively concerned with domestic affairs and that Kennedy's opening address largely discussed world relations. It is no accident that in the Washington of the 1930s the most cherished posts were in departments like Labor and Agriculture; in the 1960s, in the State Department and other foreign-policy divisions.

The foreign policy that the Post-Liberal Generation emphasizes so much breaks not only with the older liberal isolationism but also with the One Worldism of the World War II period. That, too, depended on the law of history and expected easy, total answers. The Post-Liberals rely on no law of history unless it is the law that life is tough, for nations as well as men. Their internationalism is unenchanted, pragmatic, touched with a melancholy sense of the infinite complexity of things, tremendously leery of making a wrong move. If at times they show a One Worldish enthusiasm, that is largely because they literally believe there will be one world or none. They are eager to act less because they are

sure what the next step should be than because they are certain that inaction is still more dangerous.

The emphasis in domestic affairs shows an equally important shift. Of course, the Kennedy Administration promptly made bread-and-butter moves, particularly by pushing legislation to combat the recession and by issuing Executive Orders to increase job opportunities for Negroes, but it did these things in a way which left the impression that it did not consider economics the nub of the national need. Well before the election of 1960, Arthur Schlesinger, Jr., found a phrasing for the changed concern. American liberalism, he wrote, had been "quantitative." But now, with quantitative success largely achieved in the affluent society, it should turn to the "qualitative" development of the individual. The whole Kennedyite emphasis on the intellectual is not simply a return to F.D.R.'s love of jousting with the expert and his respect for the cultivated. It also represents, quite plainly, a conviction that the man in Levittown should not live by bread alone, no matter how attractively packaged or how tasty the slices—and that if he does, the United States will pay for it by purblind foreign policy and domestic stagnation.

Closely connected with this swing to the qualitative is an attitude that might almost be called the moralistic. The F.D.R. era had been notably lacking in pulpit talk. It had a cocked-eye manner that permitted its devotees, like the writer Edgar Kemler, to exult: "With the repeal of prohibition [at the beginning of the New Deal], sin was returned to the jurisdiction of the churches where it belongs, and the present administration has shown little inclination to reclaim it." But the Post-Liberal Generation had lived through the challenge of Communism to American values and the sickening feeling that Americans may have few values left except the pursuit of money and status or, if they do, they are not quite sure what the values are. Its leaders are the men who had kept appealing for a sense of "national purpose" and they now proposed to try to find and assert it.

The most conspicuous idea in President Kennedy's Inaugural Address was the summons to Americans to break away from the gimme attitude and ask instead, What can I do for my country? The most original and, many thought, the most characteristic move of the early Kennedy days was the establishment of the Peace Corps, with its direct call for selflessness. There was nothing to get out of it, the President emphasized in his announcement. Over and over again, the Peace Corps' Director, R. Sargent Shriver, Kennedy's brother-in-law, hammered on the same point. The Corps would not make you draft-exempt; it offered no real pay. It offered only "difficult" and "dangerous" living and the opportunity for "service."

The new moralism is the more striking because it is accompanied by the most unabashed power-consciousness that the Capitol has ever known. Early in the Administration Robert Frost advised the President: "Poetry and power is the formula for an Augustan Age. But be more Irish than Harvard. Don't be afraid of power." The remark was directed to a thoroughly receptive audience. (As a matter of fact, Frost was soon saying that he had received a letter from Kennedy across which was scrawled "Power all the way.") If the Post-Liberal Generation has any one central preoccupation, it is power—"how to get it, how to keep it, how to use it," as Post-Liberal Richard Neustadt wrote. They are done with the sunny dreamings of early-1900s progressivism, done with the confidence of the New Dealers that the masses would carry things forward. They have seen power, skillfully organized in the Russian society, become a direct threat to the national security of the United States. They have watched power shifts, inadequately sensed by the liberals, turn America over to McCarthyism and to what they considered eight years of dangerous Eisenhowerism. They are students—and products—of the new managerial America, a managerial world that includes political campaigns and universities as well as business corporations, and they are acutely aware that a managerial world is one in which men and ideas are made or broken by subtle configurations of power. They are part of the swing of educated Americans to psychological and sociological ways of thinking—with the implicit warning of this kind of thinking that all human beings are manipu-

lated by a tangled variety of circumstances. They have their own ideas of good—and they intend, by a sharp sensitivity to power considerations, to manipulate men and things toward those ideas.

"Poetry and power," ideals, intellectualism, and a realism bordering on cynicism—the Post-Liberal Generation was bringing to Washington a mixed tone, one so mixed that it was akin to ambivalence. People noticed it especially as President Kennedy announced the Peace Corps. He was putting before the United States a program that in its way was just about as radically idealistic a proposal as has ever been presented to Americans—and he did it in an unemotional, matter-of-fact, almost cold tone. Ideals were back in style; but they were to be highly controlled ideals, calculated to survive the Russians, Congress, public opinion, and man himself. They were to be unideological ideals, pointed to solving specific problems. For generations, American reformers had tried to save the world. The Kennedy group appeared sure that, if the world was to be saved, it would be saved by their becoming masters of the *ad hoc.*

Jackie Kennedy, who long ago wearied of being asked what kind of a man Jack really is, eventually found a phrase that satisfied her. Her husband, she likes to say, is "an idealist without illusions." The President himself has done his own filling out of this somewhat enigmatic description. His foreign and domestic policies, he declared, "are the result of a rule of reason." Was he a "liberal"? an interviewer pressed him. "The common definition of a liberal today is an ideological response to every situation, whether it fits reason or not. I don't have an automatic commitment.... If the rule of reason happens to bring you to the position that happens to be the liberal position, it is the one you have to take, but not just because it is liberal...." But didn't his program sound like more New Dealism? "It is reasonable to say that we've got to do something about low-income housing, we've got to do something about minimum wages, we've got to do something about our schools. Reason tells me we've got to do these things."

The crisscross of attitudes, the combination of coolness and reformism, is there wherever one touches the Administration. It is in lanky, reserved Theodore C. Sorensen, thirty-three, University of Nebraska Phi Bete, Law School honors graduate, so close to the President for so long that reporters say, "When Jack is wounded, Ted bleeds," and so much the new type that newsmen use for him combinations of adjectives such as "tough" and "sensitive," "cold" and "kindly," "ruthless" and "selfless." Almost any group of top Kennedy men presents a similar picture. On the face of it there seems little in common between Special Assistant to the President for National Security Affairs, the slim, high-strung patrician McGeorge Bundy, Republican, friend and biographer of Henry Stimson, Dean of the Faculty of Arts and Sciences at Harvard; Appointments Secretary to the President, ramrod, tight-lipped Kenneth O'Donnell, son of a football coach, much-decorated World War II pilot, captain of the football team, then full-time in Democratic affairs; and Robert S. McNamara, a pleasant-faced, snub-nosed, non-political type, who rocketed from a shoe merchant's home background to become president of the Ford Motor Company at the age of forty-one. But before long, observers were noting a strong similarity between the men. All have hair-trigger minds; all are born managers; all have, tucked away in their heads, a dream of a better world—and wince if anybody mentions it.

Bundy represents the three in his impatience when people question him about the "ideology," the "larger trend" of the Administration. "We are meeting," he says in his clipped way, "day-by-day problems." As for toughness geared to high purpose, Sorensen caught the common assumption when he said of O'Donnell: "He knows better than most people that policy and politics are indivisible—and that it is our job to preserve the point of union between the two."

As the Kennedy Administration entered its third month, a veteran Republican Senator sat musing about it. "I watch these boys, study them up and down—they fascinate me," the Senator remarked to a friend. "But for the life of me I can't figure out whether they are going to be a bust or a big success. I

can't even figure how they fit into the long pull of things down here."

The long pull of things was clear enough. The years of F.D.R. were the watershed, taking the United States out of the nineteenth into the twentieth century, inaugurating the welfare state and fully launching America into the world. The Truman years were essentially an era of codification on the domestic front and of the first serious moves to recognize the necessities of the changed world situation. The Eisenhower period was in part sheer drift, in part an era of consolidation. The sunny President, so American, so Republican, was the bridge by which millions of the most reluctant part of the public moved over to an acceptance of the welfare state at home and of coexistence abroad.

Still clearer was the conception which the Kennedy group had of its own role. America, they were sure, had enough of codification, of consolidation, and of the wheedling of men into the twentieth century. Candidate Kennedy said it in his campaign; President Kennedy declared it in his addresses; the very restlessness of his advisers spoke it. It was high time for bold, innovating actions in both the domestic and foreign areas.

There was, however, a difficulty—and one big enough to give pause to more than Republican Senators. Though the voters elected John Kennedy President of the United States, they proceeded to give no particularly persuasive indications that they shared his mood. In the opening months of the Administration, poll after poll, editorial after editorial, straw-in-the-wind after straw-in-the-wind bespoke an America with a sodden resistance to being bothered. During previous decades, the American people, in the mysterious ways of the democratic process, had usually found their way to a President who reflected their temper—a Franklin Roosevelt for years of fear and turmoil, a Harry Truman for a mood of prickly transition, a Dwight Eisenhower for an old-shoes settling down. This time, had the American people, through the closeness of the vote, perhaps through the confusions created by strong religious divisions, put into office an Administration so far

removed from the public temper that inevitably the Administration would be stymied?

Kennedy and his aides were perfectly well aware of all this. They knew the mood of the country—and that the mood of the country would be the mood of Congress. The President-elect abandoned any strategy of a hundred or of ninety days before he entered the White House. Apparently the early months were to be treated as the period of the laundry list. The Administration would try to push through Congress certain measures—most importantly, anti-recession bills, depressed-areas legislation, medical care for the aged, and federal aid to education—to which Kennedy had committed himself during the campaign and for which the need seemed pressing. A strong attempt would be made to get off to a fresh start the arms-control negotiations with the Soviet Union, American defense planning, the foreign aid program, and general U.S. relations with other nations. Meanwhile the big, the basic effort would be on.

President John Kennedy would use all the enormous educational powers of his office, would use everything—his driving intellect, the folders on the Congressmen, his million-dollar TV manner, Secretary Goldberg's strength in the workingmen's bars and Jackie Kennedy's *haute couture*, McGeorge Bundy and Dean Rusk, Caroline and the professors and Soapy Williams' inspired bloopers—President Kennedy would use everything in an all-out effort to change the mood of the country and of Congress. By 1962, so the hope seemed to run, the temper would be altered sufficiently to permit the opening of an era of genuine innovation.

Will such a strategy work? Some knowledgeable observers have their doubts. They maintain that the essence of successful leadership in a democracy is emotional fire, transferring a sense of exciting commitment to the general public, and that this quality is precisely what is lacking in the gifted, hard-nosed young men of the New Frontier. The point has worried sympathetic commentators since the days when Kennedy first became a serious candidate for the Presidency and his highly favorable biographer, James MacGregor Burns, wrote that Kennedy would

undoubtedly bring to the White House "bravery and wisdom; whether he would bring passion and power would depend on his making a commitment not only of mind, but of heart, that until now he has never been required to make." It kept on bothering friendly observers throughout the infinitely calculated primary and Presidential campaigns, the assembling of the no-nonsense Post-Liberals in Washington, and the first carefully burnished days of the Administration.

Along with others, the pro-Kennedy columnist Doris Fleeson warned: "Efficiently, almost coldly, President-elect Kennedy and his new team of intellectuals, investment bankers, management experts and bright young men are taking over their Washington assignments. But it is already clear that a fascinating and power-laden quality is sadly lacking—and that is personal fervor, with all that it means in warmth, excitement and flair….The art or trick of leadership is not just rational action, but articulation of it in ways that reach the public's heart as well as mind. Kennedy seems almost to have set for himself the Talleyrand motto: 'Above all, no zeal.'"

When the Easter Congressional recess came and the Representatives and Senators went home to sound out their constituents, the worriers worried still more. Almost unanimously the Congressmen reported back that John Kennedy was quite popular personally but that he seemed to be generating little or no additional support for his attitudes or his specific proposals. Pro-Kennedy leaders, the New York *Times* noted, were concerned about "the President's failure to fire the general public with enthusiasm for his legislative program."

Yet there were countersigns. However slowly, the Administration bills *were* moving through Congress—and at a faster rate than during the opening months of the Eisenhower Administration. When Kennedy stubbed his toe on Cuba and came out of the experience declaring that America needed a fundamental rethinking of its foreign programs, a notable surge of public opinion agreed with him. All the while the Peace Corps, the most offbeat of the Administration proposals, continued to provoke a response that surprised even its enthusiasts. "This President," said one college president, "has touched something in the oncoming generation that the young people themselves did not realize was in them."

It could be that there was a Post-Liberal America as well as Post-Liberal leaders. It could be that this America knew, in its heart of hearts, that things should change and was gradually, warily, responding to men who managed to say so without arousing that supreme fear of the 1960s, the fear of fervor.

This essay was originally published in *Let Us Begin: The First 100 Days of the Kennedy Administration*, New York: Simon & Schuster, 1961, and appears here courtesy of Simon & Shuster.

Eric F. Goldman was an educator, historian, and author who served as a special consultant to President Lyndon B. Johnson. His books include *Rendezvous with Destiny* and *Tragedy of Lyndon Johnson*.

Cornell Capa was born in Budapest in 1918 and has lived in New York since 1937. He was a photographer on the staff of *Life* magazine from 1946 until May 1954, when his brother, Robert Capa, was killed by a landmine in Indochina. Cornell then joined Magnum Photos, the agency that his brother co-founded. During his Magnum years, he traveled to the Soviet Union and covered the Israeli Six-Day War, but his most extensive projects focused on politics and poverty in Latin America, on social issues in the United States, and on American presidential politics from Adlai Stevenson to Barry Goldwater. In 1974 he founded the International Center of Photography in New York, and served as its director for twenty years. Since his retirement in 1994, he has worked on numerous books and exhibitions, and he remains one of the photographic community's most respected elder statesmen.

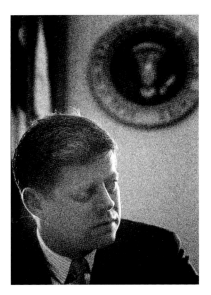

President Kennedy during a cabinet meeting, March 2, 1961

Published in conjunction with the exhibition JFK for President: Photographs by Cornell Capa organized by the International Center of Photography.

Exhibition Dates: September 17, 2004 through November 28, 2004.

This exhibition was made possible with lead gifts from the Alex Hillman Family Foundation, Stephanie and Fred Shuman, Bicky and George Kellner, Tony and Dominique Milbank, Ethel & Irvin Edelman Foundation, Estanne Abraham Fawer, Linda Hackett for C. A. L. Foundation, Lynne and Harold Honickman, The Liman Foundation, Mr. and Mrs. Ted Nierenberg, Ronny Schwartz, Marshall Sonenshine and Sonenshine Pastor & Co., and Lester Wunderman. Additional support was provided by Eastman Kodak Company, Norman H. Gershman, Peter Howe, Herbert Keppler, Arthur and Dolores Kiriacon, Mara Vishniac Kohn, Magnum Photos New York, Magnum Photos Tokyo, Mamiya-MacGroup, Nikon Inc., Susan Unterberg, Claire and Richard Yaffa, and Lois and Bruce Zenkel.

First edition 2004

Copublished by the International Center of Photography, New York, and Steidl Publishers, Göttingen, Germany
© 2004 for this edition: International Center of Photography, New York/Steidl Publishers, Göttingen
© 2004 for the photos: Cornell Capa/Magnum Photos; p. 9, bottom right © Bettmann/Corbis

Publications Manager: Karen Hansgen
Editors: Richard Whelan, Kristen Lubben
Copyeditor: Martin Fox
Design: Steidl Design/Bernard Fischer, cover: Claas Möller
Separations: Steidl's digital darkroom
Production: Steidl, Göttingen

 International Center of Photography
1114 Avenue of the Americas
New York, NY 10036
www.icp.org

STEIDL
Düstere Str. 4
D–37073 Göttingen
Phone +49 551-49 60 60 / Fax +49 551-49 60 649
mail@steidl.de
www.steidl.de

ISBN 3-86521-064-3
Printed in Germany